PETER PAUL RUBENS

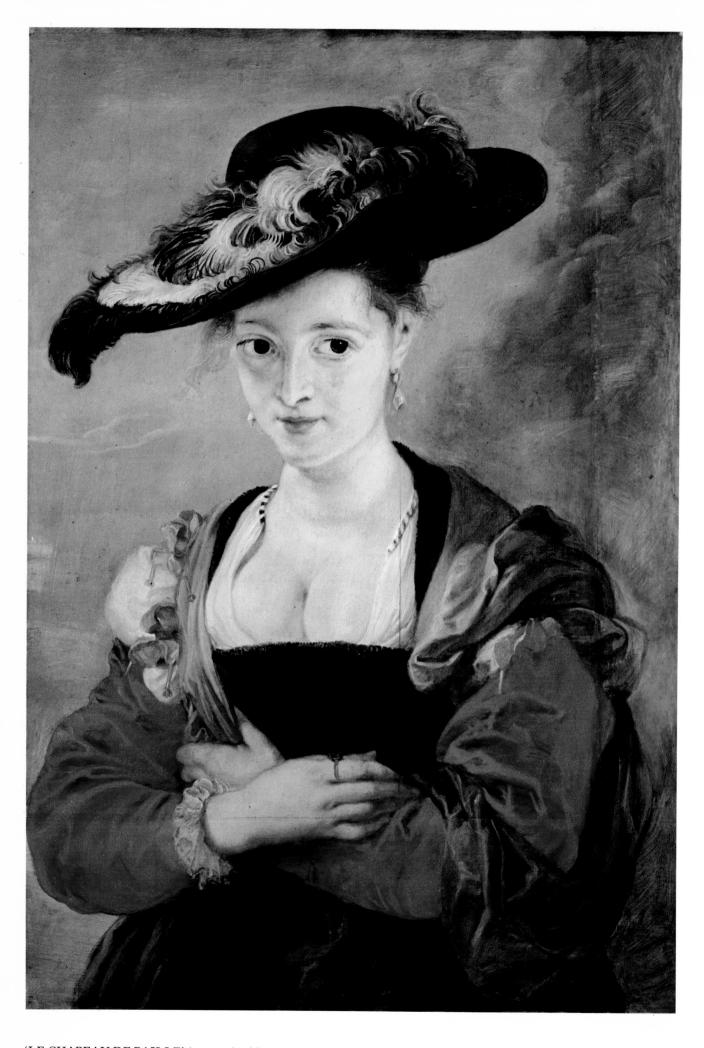

'LE CHAPEAU DE PAILLE' (a portrait of Susanna Fourment ?). About 1625. London, National Gallery

PETER PAUL RUBENS

by Jennifer Fletcher

with fifty plates in full colour

Phaidon · London · New York

© 1968 Phaidon Press Ltd \cdot 5 Cromwell Place \cdot London SW7

Phaidon Publishers Inc · New York
Distributors in the United States: Frederick A Praeger Inc
111 Fourth Avenue · New York · N.Y. 10003

Library of Congress Catalog Card Number 68-27418

SBN 7148 1340 0

Made in Great Britain
Text printed by Hunt Barnard & Co Ltd · Aylesbury · Bucks
Illustrations printed by Ben Johnson & Co Ltd · York

PETER PAUL RUBENS

Today Rubens is often admired but rarely liked; whereas in his own lifetime he was famous, fashionable and commercially successful. His intelligence extended beyond his art. He was sociable and articulate: hundreds of letters give evidence of his opinions, taste and commissions. We know far more about Rubens than we do about Rembrandt; and yet Rubens' life, with its contrasts between domestic tranquillity and international diplomacy, has somehow failed to capture the popular imagination. The circumstances of his life have been too crudely related to his art and have failed to illuminate his attitude to painting. In point of fact, Rubens has always been a little 'suspect', and is nowadays often accused of insincerity and vulgarity. His very brilliance and the incredible speed and ease with which he worked seem less impressive to the twentieth century than they did to contemporaries.

There are other barriers to an uninhibited appreciation of Rubens' art. Rubens was a devout Catholic who often painted for propagandist religious orders, such as the Jesuits, and most people reading this book will be deeply conditioned by Protestant traditions. His vision of female beauty is remote from contemporary ideals. He frequently used difficult symbols and allegorical figures whose meaning, though apparent to his contemporaries, we now have to look up in books. Today we tend to sympathise more easily with painters, like Rembrandt, whose work was not, in fact, always in accord with seventeenth-century assumptions about art. We like the idea of struggle, isolation and introversion. Not one of Rubens' many letters gives any hint of neurosis or of a creative crisis. It is disconcerting to find an artist openly boasting as Rubens did in a letter of 1621: 'My talents are such that I have never lacked courage to undertake any design, however vast in size or diversified in subject.' It is not comfortable to listen to Rubens as he advertises his own work, recommending his paintings and whetting his patron's appetite with promises of 'many beautiful nudes'.

Such objections to Rubens should not be casually swept aside. We have to admit that this is an artist who enjoyed painting rapes and naked women; and if we examine seventeenth-century reactions we find that in England, for example, there was some doubt about the

tone of the mythological paintings that Rubens might produce for the Queen's bedroom at Greenwich. The agent in charge of this commission was instructed to see that the painter did not produce 'drunken-headed imaginary Gods'. A quick look at the Dresden *Bacchanal*, which is no Renaissance study in Dionysian ecstasy but a brutal description of physical incapacity, shows us exactly what they had to fear.

There are many different levels in both Rubens' standards and accomplishments. A painter working on such a scale and under such pressures could not always bring his deepest concentration to the work in hand. Rubens also accepted the seventeenth-century belief in a strict hierarchy of subject matter: it was better to paint Christ taking his supper at Emmaus than a group of peasants drinking in an inn. If we read Rubens' letters carefully, it will become clear that he went even further. The fact that a subject came from the Bible did not necessarily entitle it to elaborate and reverential treatment. An episode such as Abraham dismissing Hagar was to Rubens rather trivial and therefore suitable for a small scale panel painting. A Bathsheba (Plate 44) was obviously not meant to be worshipped in a church; it was a collector's piece, an Old Testament Venus at her bath, an open invitation to erotic thoughts. Here Rubens is different from Rembrandt for he works within traditional subject matter. Rembrandt was interested in visualising obscure and previously unillustrated Biblical subjects. But then Rembrandt lived in a country where church walls had been whitewashed and the market for religious art had violently contracted. Rubens accepted the expectations of patrons whose tastes had been influenced by sixteenth-century Venetian painting through conscious quotation. He will remind them that a Veronese, a Tintoretto or a Titian lies behind his own rendering of a subject.

It is comparatively easy to become involved in a single painting by Rembrandt, but many people, even though they easily recognise Rubens' style of painting, find it difficult to recall individual pictures by him. They acquire a generalised conception of his work, a glorious amalgam of martyred saints and riotous bacchanals. But in doing so, without probing deeper, the layman misses one of the most exciting aspects of Rubens' life and art. He will not perceive the painter's brilliant stage management of his opportunities, or see him limbering up like an athlete, sometimes holding himself in reserve, even turning down commissions that he felt were beneath his capability or would typecast him in the wrong role. Rubens' sense of his own destiny, his unshakable belief in his own power and in the originality of his own way of applying paint cannot be ignored if we are to understand his paintings fully. In the same way, we should try to accept, frankly, Rubens' aesthetic self-consciousness. We can meditate with a Rembrandt prophet, we are drawn into the stillness and our visual reactions grow slowly almost as if in harmony with the rate the picture itself grew. After a time we can almost forget that we are looking at a picture at all. But when we study a Rubens' Madonna ascending to Heaven (Plate 7), we sense Rubens at work, making the picture. The way he has visualised the scene may be powerful and impressive, but we only temporarily believe that it could happen that way. The movement in his paintings prevents contemplation; it is hard to get lost in the event. With Rubens, we are always aware of Art.

This was intentional. Rubens' art was consciously derived from works of the Italian sixteenth century, and the more we know about sixteenth-century art the better will we appreciate his achievement. Rubens will paint a 'Fine Art' Assumption which should remind us of other great Assumptions by Titian and Annibale Carracci. It is not just a picture of the Virgin going up to heaven, a brilliant illusion of a momentary revelation, it

is Rubens showing us that he can out-paint the Italians at their own game. This is deliberate incantation. The Madonna is magnified by technical virtuosity. It is not easy to disentangle the glory of Rubens from the glory of God. Pure technical skill, however, is constantly under-valued in this century and Rubens' type of excitable, elevated, self-generating, self-conscious creativity is not prized, as it should be. In literature, Milton has already fallen to the axe for comparable reasons.

Rubens has remained a painter's painter, and artists have made the most perceptive criticisms of his work. His art, so rich in quotation, has bred great painting in its turn. Rubens has shown a few artists what to paint, but to the majority he has revealed a way of applying paint and harmonising colours. Rubens is the great undenominational painter and his work has been accessible to artists of different nationalities, temperaments and interests. A study of Rubens can serve as a brilliant introduction to Baroque art but it can do more than this. It can teach us to think outside the limitations of centuries and it can lead us to reconsider the innumerable ways in which one artist can influence another. Artists have found Rubens' work relatively easy to break down. In using Rubens they have not felt themselves totally committed to a certain taste or dogma. Rubens, like Titian, is open to highly fruitful misinterpretations.

Rubens can, and has been, referred to on many different levels. His work helped Renoir achieve the pearly flesh tones of his Grande Baigneuse. Watteau copied several of his chalk drawings and studied the Marie de' Medici cycle (Plate 18) attentively. Constable lectured on his landscapes at Hampstead. Cézanne made drawings from the Marie de' Medici cycle, and Kokoschka was able to study Rubens modelli when painting a ceiling in a London house which contains a large collection of Rubens' work. If we know nothing about Rubens, we cannot hope to understand Delacroix, who, quite consciously and somewhat emotionally, pitched his art in a Rubensian key. Delacroix saw Rubens as the Romantic hero, the anti-academic, the genius who could break the rules. Delacroix is one of the few artists to gain an overall view of Rubens' career and perhaps only he has really tried to define Rubens' originality. He admired his power of conveying energy and feeling, of controlling visibility and commanding a response over vast architectural spaces. He saw that Rubens' colour was not purely 'scientific' in application, used only to record optical facts, but that it was also a means of conveying emotion. Delacroix's art grew out of Rubens and he needed Rubens' skills and fluency. He studied many of the paintings reproduced in this book, copying the Rape of the Daughters of Leucippus (Plate 15), the Battle of the Amazons (Plate 13) and the Reception of Marie de' Medici (Plate 18). In his journal he struggled to describe the nature of his own response to Rubens' work. He tried to describe his sense of shock and rapture and he rightly connected it with the Michelangelesque scale, terribilità and distortion in Rubens' art.

We can learn a lot about twentieth-century attitudes to Rubens just by considering the plates selected for this book. There are a high proportion of coloured sketches and paintings made by Rubens for himself. In this century we have placed great emphasis on creativity, improvisation and the whole process of making a picture, as a private act, in which feeling is of more account than intelligence. But even though this makes it very hard to see Rubens as contemporaries saw him, his work is so rich and varied that it can happily support more than one interpretation, and provide an infinite variety of pleasure. Rubens will interest those who believe that paint should have an exciting texture, that it can be beautiful in itself and that it should not hide behind the objects that it describes. They will admire Rubens' ability to animate a large surface, to use the colour of the wood

panel as a unifying factor, to turn nude forms fluently in and out of space, and to distort forms in the direction of an overall rhythm. In a curious way a Rubens can stand not only as a beautiful picture but also as an attractive idea. Rubens will remain part of many people's private mythology, for we still need giants and genius figures, artists who will constantly remind us of the complexity of art and of the limitations of language when applied to it. He is a very 'visual' artist, who makes his effect on our seeing rather than our thinking, a man who has been able to paint certain surfaces so satisfactorily, and realised them so completely, that it is now hard to see real flesh or a real sunset except in his terms. As long as Rubens' paintings are attacked with razors, as long as his nudes disappear from library books, we can rest assured that a large part of his message is still 'getting through'.

One of the main problems that confronts anyone who studies Rubens is the sheer size of his output. For this reason, it is easier to come to grips with his art by considering various isolated aspects.

RUBENS AND THE ANTIQUE

In the seventeenth century most artists drew from classical sculpture or from casts; it was part of an orthodox art training, since classical sculpture still retained the authority which it had exercised over artists of the High Renaissance. By looking at classical art, a young artist learnt to reproduce a certain selection of idealised types, forms, contours and gestures. Art theory still leaned heavily on Aristotle's Poetics and Plato's conception of ideal form. Great art was a kind of frozen theatre; the artist's figures were actors, they relayed a dramatic story through dignified gestures and suitably noble expressions. Study of classical art was supposed to teach one how to do this well, and young artists were advised to work from the antique until they had learnt to see life in terms of classical prototypes. A sculptor like Bernini was proud to admit that in his youth, when in difficulties with a statue, he had gone to the classical figure of Antinous 'as to the oracle'. This statue of a nude youth, in the Vatican gallery where it was also studied by Rubens, was then considered to be one of the most important statues of antiquity. Poussin firmly believed in 'those fine old Greeks, who invented everything that is beautiful,' and Caravaggio was criticised for challenging the superiority of classical art and for suggesting that flowers were as hard to paint as human beings.

Rubens' position was rather complex, since he was less dogmatic, less convinced of the benefits to be derived from the study of classical art than most of his contemporaries. In an essay that he wrote on the use of classical sculpture he explained that while it was good for some artists it was so harmful to others 'as to destroy their art'. In other words what might be good for Rubens might not be so good for someone else. It is worth remembering that Van Dyck, Rubens' most brilliant pupil, found Rome uncongenial and was constitutionally uninterested in the antique. We must remember that Rubens had an eye for good painting, almost irrespective of its style; he judged pictures on how they looked, not on the quality of the ideas that lay behind them. Rubens admired Caravaggio and copied from Michelangelo, and he owned Elsheimers as well as Titians. He could re-use the figure of God from the Sistine Ceiling or a peasant from Bruegel. He never concealed his own empiricism or subjectivity. He had preferences for certain kinds of classical work and clear ideas on quality. He could extract information on armour or

iconography from a Roman relief but this did not mean that he found it beautiful or stylistically sympathetic. Unlike Poussin, he never fell in love with the clarity, the stiffness or the actual archaic qualities of certain reliefs. Rubens was not temperamentally addicted to order; he did not 'flee confusion as day the night'; rather, he revelled in the energy and confused movement of the great battle sarcophagi.

The difference between Rubens' and Poussin's response is made clear in their reaction to a book written by Francis Junius containing descriptions of the lost paintings of antiquity. Poussin was very enthusiastic and was stimulated by it to elaborate his theory of the Modes; but Rubens qualified his praise. He suggested to the author that it might have been more useful to describe works of art by modern Italian painters for these paintings still existed: 'one might point to them with the finger and say "there they are". Those things which are perceived by the senses produce a sharper and more durable impression, require a closer examination and afford richer material for study than those which present themselves to us only in the imagination'. Poussin could talk about judging pictures with reason rather than compulsion, but Rubens' art is aggressively seductive, sensual and full of unconcealed erotic appeal. Both Rubens and Poussin were very erudite but Rubens' intelligence seems more compartmentalised. His art grows out of visual stimuli: a naked backside, a Roman goddess or a Venetian canvas. Unlike Poussin, he could not work up his imagery from a philosophical idea; although an antiquarian, he had no special interest in classicism as a general concept. He did not deal in abstractions, he did not – as he said on the death of his first wife – feel that one could be equally indifferent to all things in this life. Rubens' rate of creativity was far faster than Poussin's and he needed constant stimuli, an ever expanding vocabulary of classical forms. He was interested in the tangible aspects of antiquity, in Roman history as well as in mythology. The esoteric had little appeal for him. He insisted that marble must be transformed into 'living flesh' and for this reason, most of the drawings after the antique are made with soft chalk. His whole art is directed to the animation of the surface.

Rubens shared his interest in surfaces with Bernini, who might even have been encouraged in his approach by Rubens' example. Both artists worked for Scipione Borghese and knew the sculpture in his collection. Both were attracted to large figure groups, to the Farnese Bull and the Laocöon, which so successfully evoked violent movement. The work of sixteenth-century artists like Michelangelo, whose style was to some extent grounded on them, appealed to Rubens and Bernini for similar reasons. Both were so involved with classical objects that they instinctively identified classical characters with particular classical statues. To them Hercules meant the Farnese Hercules (Fig. 8), while Apollo meant the statue in the Belvedere. Rubens' artistic aim was quite straightforward. He wanted to bring the world of the antique sarcophagi back to life, simply to make that world more plausible and three-dimensional. Any source that would help him became important. Rubens was not deeply interested in fifteenth-century art, but he copied Mangegna's Triumph of Caesar (Fig. 10) because he felt that it contained authentic information on the appearance of a Roman Triumph.

Rubens could use a small-scale prototype for a giant-size picture; he could convert an Adonis into Christ, a Roman matron into a Christian saint. He had an exceptional visual memory, and figures originally copied from someone else soon become a natural part of his own visual vocabulary. We can sometimes recognise such borrowings when he 'thinks aloud' in his *modelli*, but on other occasions we fail to recognise them, so

transformed are they by the personal rhythm of Rubens' brush-strokes. Rubens used words as well as images to stimulate his imagination. He couldn't restrain his joy when he discovered an uncut manuscript describing a classical orgy in a Spanish library. Sometimes, as he painted his scenes from Ovid or his Bacchanals, portions of the classical texts were read aloud to him in the original Latin.

It is not easy to set a limit on Rubens' debt to antiquity; it was never just a case of a year or two's culture in Italy. Antiquity and its history was part of his way of life; his private letters were larded with Roman proverbs, and mottoes from Seneca and Juvenal were carved above his doors; he was respected by the most scholarly antiquarians of his day. His house was full of classical sculpture. His son was trained to write essays on tripods, and his wife even used a light-weight classical porridge spoon when she was pregnant. His brother Phillip was an accomplished classical scholar and Rubens illustrated his books, and from this correspondence we can see Rubens learning through his eyes. Rubens' attitude to subject matter made several antiquarians look silly. He looked harder at objects than they and applied common sense to what he saw. It is amazing that Rubens was not weighed down by his own erudition but that erudition, like his technical fluency, seems to have been easily acquired.

Perhaps Rubens was saved from dryness by his interest in narrative, for even as a young man in Rome we can watch him trying to animate his sculptural models. He often drew from the same pieces, as his near contemporary Golzius, but unlike Golzius, he rarely tries to reproduce the sensation of marble. With Rubens it is almost as if he is already thinking of some context in which to use the figure. He will draw from unusual angles. He can disturb our preconceived conception of a figure by drawing it steeply foreshortened or by creeping around the back to take it from an unfamiliar, almost unrecognisable position. He shines a light on Michelangelo's Battle of the Centaurs, draws it once and then illuminates it from the other direction and draws it again, fascinated by the instability of appearances. In his letters he constantly apologizes for his black and white drawings and will give loving descriptions of the flaws in the marble, of transitions in colour from whites to creams to browns. Like Bernini and Michelangelo, he recognised the emotional impact of violent foreshortening, and as with Guido Reni, his conception of physiognomical suffering was based on the upturned head of the father in the Laocöon group. This experience is behind his drawings for the Antwerp Raising of the Cross, it can be sensed in his oil sketch of two Apostles' heads from the Bromley Davenport collection (Plate 27).

Rubens' idea of 'great art' was based on classical precepts and in his oil sketch for The Horrors of War (Fig. 11) he symbolizes the death of art in a drawing of the Three Graces which is trampled underfoot by Mars the God of War. Perhaps we can best see Rubens' relationship to the antique by looking at a late painting of The Three Graces now in Madrid (Plate 48). Already by this date the subject had merged in Rubens' mind with the Judgment of Paris. The Graces were constantly represented in antiquity and to the seventeenth-century spectator the subject was charged with classical associations. Raphael had made the definitive High Renaissance comment on the theme. For Rubens this is a statement on the female form in triplicate. The classical origin is not so obvious, it is hardly a memory; but the women are built on the scale of the Venus de Milo, even though, at the same time, they are 'softened into living flesh.' Rubens wishes us to feel that this is 'nature not art'.

We see things that no one else has painted before, flesh which is loose enough to quiver

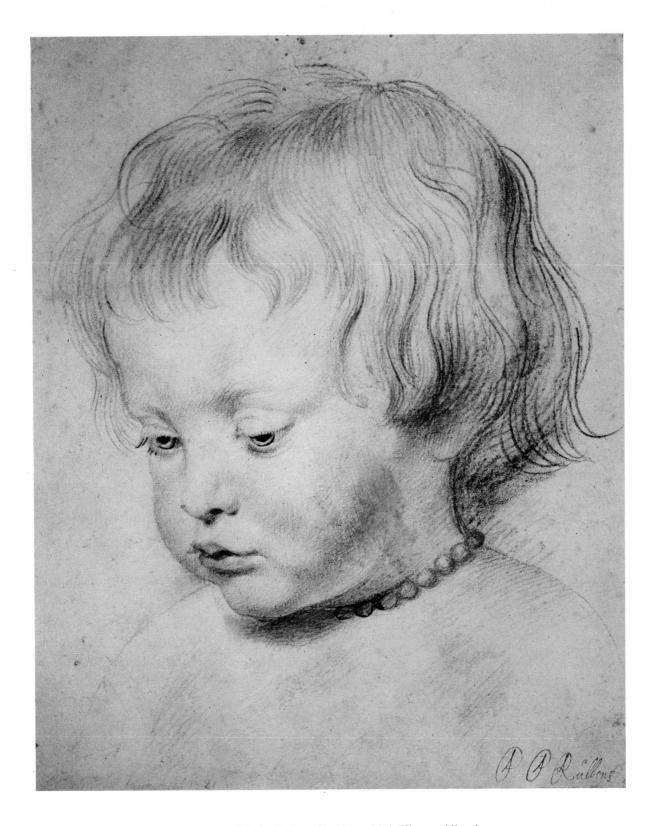

PORTRAIT OF A LITTLE BOY (Nicholas Rubens?). About 1619. Vienna, Albertina

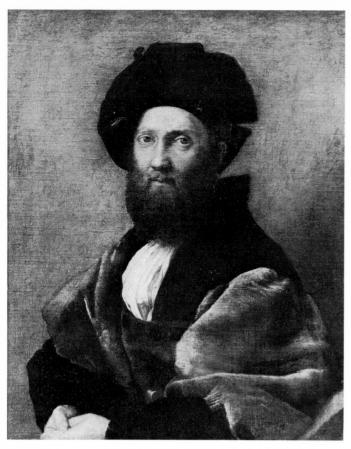

Fig. 1 PORTRAIT OF BALDASSARE CASTIGLIONE (by Raphael). Paris, Louvre

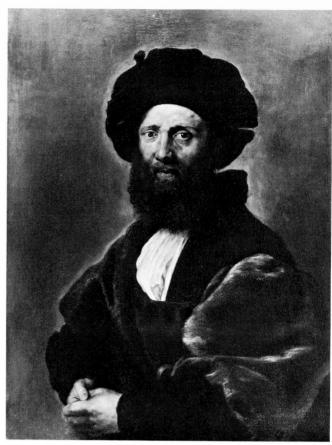

Fig. 2 COPY OF RAPHAEL'S PORTRAIT OF CASTIGLIONE. London, Count Antoine Seilern

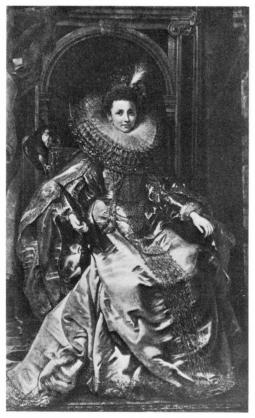

Fig. 3 PORTRAIT OF THE MARCHESA BRIGIDA SPINOLA-DORIA. About 1606. Kingston Lacy (Dorset), Bankes Collection

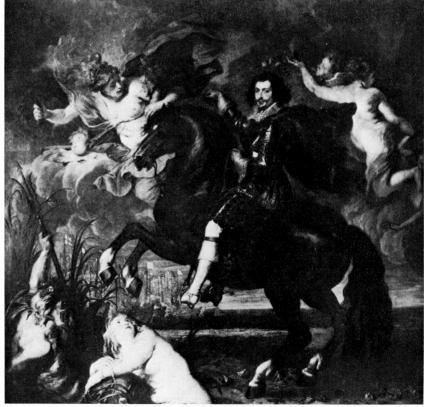

Fig. 4 PORTRAIT OF THE DUKE OF BUCKINGHAM. About 1625. Formerly in the Collection of the Earl of Jersey (destroyed)

and shake. We see creases under the arms, dimples around the base of the spine and indentations where the figures grasp each other. These details, observed from living models, are absorbed into the rhythm of the general contour. Rubens'eye, disciplined by the study of classical form, does not have to concentrate on one aspect, and is free to focus on another. He has re-directed his looking – but within the framework of classical art. The ancient meaning of the Graces, those who give and receive, is truly re-inforced by Rubens' treatment. The Grace viewed from the back, so often a central accent in earlier designs, is now off-centre. It is difficult to separate the action which is, as it should be, completely reciprocal.

In his late work Rubens seems to be stressing the tangibility, pushing his illusion at us by forcing the painted figures to touch or to take hold. Chain movement and dancing become his ideal. Looking at this picture we see why Rubens cannot, like Rembrandt, paint deliberately anti-classical pictures. He will not search conscientiously for an alternative ideal although he will occasionally borrow one from someone else. His eye was 'elevated' early in Italy, where he saw classical art in its proper setting. The result is not as is so often implied a simple blend of northern realism and Italian idealism. It is more complex than that. A personal way of moving the brush, an astonishing response to complicated colour harmony, a personal attitude to the surface, an extraordinary visual memory – all these have produced something which is usually called typically Flemish. It is less clever but more honest to call it typically Rubens.

THE DIPLOMATIC CAREER

Had Rubens never touched a brush, had he never even seen a picture, many of us would have at least heard his name. The historians of this century would have been unable to resist him and we should have read of a certain Peter Paul Rubens, diplomat, in some well-bred Sunday review. In the National Gallery in London there is a small coloured sketch (Fig. 11). The large picture which grew out of it was completed by 1638. It was probably made for Ferdinand de' Medici the Grand Duke of Tuscany. It is not the kind of painting that art students copy, or many people stop to look at, and yet it deserves attention, for it is a denunciation of war. This work should show us to what degree Rubens' deep involvement in international politics in the 1620's influenced his handling of certain themes. The type of subject had meant a great deal to him. In 1635 he was involved in designing temporary triumphal arches which were to be erected in Antwerp to celebrate the visit of the Cardinal Archduke Ferdinand of Spain. Rubens' designs were not purely triumphal for they contained warnings on the economic crisis that had hit Antwerp since the blockading of the River Scheldt by the Dutch. Rubens painted Mercury, God of Trade, deserting the city. On another of the arches he suggested that war was imminent and painted Janus the Roman War god bursting out of his temple.

Rubens had been a top-ranking diplomat employed by Isabella, Regent of the Southern Netherlands. He had worked on briefs from Spain and his mission was to bring Holland back in to the Spanish Catholic fold. It is interesting that Rubens, in contrast with the majority of diplomats, held fast to the completely unrealistic belief that Protestant Holland would surrender her independence. Rubens had close diplomatic and family contacts with a group of Dutch Catholics and through them he seems to have gained an entirely distorted view of the situation within Holland itself. Rubens threw himself into

a strenuous diplomatic career only because he quite sincerely and deeply believed in the possibility of peace. When he was in London in 1630 he acted on his own initiative and made a private visit to the Dutch ambassador. Risking personal insult, he implored him to reopen negotiations. If he had been successful, he would not have retired from politics in that year. Rubens was used to seeing his art used as a pawn in a political game. Not far from his *Horrors of War*, in the National Gallery, is his picture illustrating the *Fruits of Peace*, which he presented to Charles I in 1630 to set the seal on the King's promise to pursue a policy of peaceful co-existence with Spain; a policy that Rubens and his employers thought would encourage the Dutch to do likewise.

Rubens explained the meaning of The Horrors of War in a letter that he sent to the Flemish painter Sustermans, who was to unpack the picture on its arrival in Florence. He explained that the woman in black is Europe ravished by war and stripped of her wealth. In the centre Venus, goddess of Love, tries to hold back Mars, the god of War. Above them the classical Furies bring famine and disease. Architecture is represented by a man with compasses thrown down on the ground and Harmony is symbolized by the female musician with the lute. Now, Rubens is frequently charged with insincerity and many of the guides at the Pitti Gallery seem to think that this picture is an outsize excuse for the painting of nude figures. It is true that a 20th century spectator might be tempted to ask why Rubens doesn't give us a more documentary account of war, why he doesn't do it like Callot and show us troops looting and burning villages. Rubens' own letters contain vivid accounts of refugees struggling towards the Dutch frontier, of outbreaks of plague and dysentery, but we must remember that Rubens is a cosmopolitan artist and that his art, like Titian's, had an international circulation. Rubens' messages had to be understood in Protestant London and in Catholic Madrid and just as there was a special diplomatic language so there was a diplomatic style in painting. Allegory is the Latin, the international code, of seventeenth century art and con-

temporary treatises on poetry extol it as the most important branch of literature. In the seventeenth century it becomes a primary means of expression. We are no longer used to elaborate images like the Ship of State. We do not think of good luck as did Rubens, who describes it in a letter as a 'woman turning her back'. Our thoughts do not easily freeze into figures and phrases like the 'Wind of Change' which crop up occasionally in political speeches. They are no longer a living part of our language. Rubens could not paint, like Bruegel, Dutch soldiers sacking a Belgian village because he did not wish to illustrate a particular historical war. He wanted to make a grandiose denunciation of all war. If we read Rubens' own letters we shall see him instinctively drawing on classical quotations when trying to describe personal emotion. If a friend dies he does not indulge in an account of his own sorrow but will choose to distance himself from the tragedy by finding an appropriate quotation from Horace to cover the event.

Diplomacy involves constant compromise and Rubens knew what this meant in terms of painting. He was only able to do justice to the rather inglorious episodes in the life of the French Queen Mother, Marie de' Medici, because he firmly believed in the Divine Right of all kings and could sincerely make direct visual comparisons between her birth and Christ's nativity, her marriage and that of Joseph and Mary. Rubens was well aware that the commentator who showed this series to Marie's son, Louis XIII, had to change and conceal the true meaning of the pictures 'with great skill'. Rubens felt that the whole cycle would have caused less embarrassment had he been left to arrange the subjects himself. We must remember that Rubens the artist suffered at the hands of

Rubens the diplomat. His support and reception of the exiled Marie de' Medici led to a temporary ban on Rubens' engravings in France and meant the end of his plans to decorate another gallery in the Luxembourg palace with paintings depicting the reign of her husband Henry IV. In his own *Horrors of War* Rubens has evolved a personal commentary on the situation. War affects culture for it can destroy literature, painting, music and architecture. Rubens the diplomat failed to negotiate a peace and Rubens the artist might have to pay for that failure. Picasso could do nothing about the planes that bombed Guernica but Rubens is painting something that he feels partly responsible for. His letter to Sustermans ends with an illuminating postscript. With rather uncharacteristic but perhaps significant humility, Rubens tells this mediocre artist that should the picture be damaged or should the artist not find everything to his satisfaction he has Rubens' permission to retouch the work.

It is of course hard to prove that Rubens' personal involvement in international affairs deepened his conception of allegory but this picture shows us how Rubens can enliven allegory, how he can impose on it all the passion of a mythological episode. Rubens' diplomatic career did enrich his art in a very direct way for it gave him continual opportunities to study the important Venetian paintings and the great European collections. We should remember that the buyer of *The Horrors of War* was educated on Venetian art and that he might respond more immediately than we do to the implications in the figures. To him the Venus who hangs on to Mars could be related to that Venus, in Titian's painting, who tries to restrain the young Adonis before the hunt. We should realise how appropriate it is that Rubens, the second great international artist, should follow so closely the solutions of the first. The meaning of this picture is reinforced in every colour and in every form. Europe is not just a fat woman about to fall. She is a tottering, unstable, crow-like shape doomed by her attributes and also by her black. Conflict is actually physically there in the picture, in the two clashing reds that rip across the centre of the painting.

SOCIETY PORTRAITS

When Rubens was painting portraits, weddings could still be made by proxy and a portrait could still make or break a marriage. Portraits were a part of politics; in the sixteenth century the Venetian Senate had voted to offer Titian's services to would-be allies. In the seventeenth century, portraits were still taken very literally and they often acted as a real substitute for an absent king or general. Travelling fast from Court to Court, portraits were important taste-makers and trend-setters, often compared, frequently exchanged and nearly always talked about. Patrons learnt about art more easily through their own portraits than by studying subject pictures, for they felt freer to criticise a likeness than to question the principles underlying the composition of a history painting. This led to a curious situation. In seventeenth-century theory, portraiture came low down in the hierarchy of subject matter but in practice a skilful portrait painter was all-powerful, since he was concerned not only with a record of a face but also with an elaborate comment on his sitter's social status. In making this statement, a portrait painter of talent might also manage to imply much about the degree of social distance between his patron and himself.

When Rubens arrived in Italy, at the beginning of the seventeenth century, Flemish

portrait specialists (like his Mantuan colleague, Pourbus) were the acknowledged experts, earning high salaries at the Italian Courts. Rubens wrote very little about portraiture, but there is evidence to show that, initially, he was afraid of being confined to a narrow career as a court portraitist. In 1603, he actually refused to paint a series of French Court beauties for his patron, the Duke of Mantua. A pin-up set of anonymous French courtesans was unworthy of his time and talent – although an opportunity to paint an influential patron, the politically powerful Duke of Lerma, or the wife of a leading member of the Genoese nobility was quite another matter.

The Genoese aristocracy was notoriously proud. With Brigida Spinola-Doria (Plate 1), Rubens was also painting a sitter whose family owned paintings by Titian. He was to meet this situation again and again. Conscious of the fact that his portraits would hang beside great examples of sixteenth century portraiture, he made a point of studying the sources of the international portrait style, copying the head from Titian's equestrian portrait of Charles V, and Raphael's Baldassare Castiglione (Figs 1 & 2). In the portrait of Brigida Spinola-Doria, Rubens tried to achieve a sense of social distinction by means of imposing architectural details. Brigida is part of the palace in which she hangs. In the seventeenth century portraits were not always painted from the life. Many artists did not even see their sitters, and were asked to base their likeness on older pictures. Patrons became bored with long sittings, and artists had to be content with an hour or two at a time. Rubens had probably one or two short sittings in which he made detailed drawings of heads and hands and a more rapid compositional sketch with notes on colour and costume. Patrons expected an elaborate account of their clothing, and an artist often found himself painting clothes which had been specially ordered for a portrait, and which were worn by a model or draped on a lay-figure. The artist could not invent, he was expected to be accurate, with the result that costumes can now be reconstructed completely from the evidence supplied by portraits. Patrons were preconditioned to expect a certain range of gestures and a certain type of setting and might not take kindly to drastic innovations. The Doria portrait, however, is quietly remarkable in that Brigida, unlike the ladies in paintings by Mor and Pourbus, does not ostentatiously finger a crucifix or pendant; nor does she support herself against a table top. The impression is not of a portrait pose but of a figure only momentarily at rest; she has stopped to look at us and will soon move on.

In this picture we are presented with the sitter, as it were, in close-up. And unlike the women in many society portraits of the time, Brigida is allowed a personality, she responds to the spectator and is about to smile. She wears her elaborate costume easily and naturally. Its details are not laid stiffly across the surface – as in an English Elizabethan portrait – but are everywhere related to the human body beneath. But then Rubens was always able to combine a sense of detail and surface texture with a feeling for the underlying structure of a form; and we can see how he simultaneously controls all parts of his portraits if we looked at his unfinished picture of the Duchess of Buckingham at Dulwich (Plate 23).

When we look at Rubens' portraits of women we should remember that changes in fashion can condition an artist's choice of viewpoint and his selection of forms. A huge ruff was very difficult to handle for it could so easily lead to the isolation of the head from the body. In the Doria portrait its slant is echoed in the angle of the crimson drapery above, and against this slightly exaggerated angle the turn of the head and the displaced necklace underline the impression of a sitter confronting an audience. Rubens'

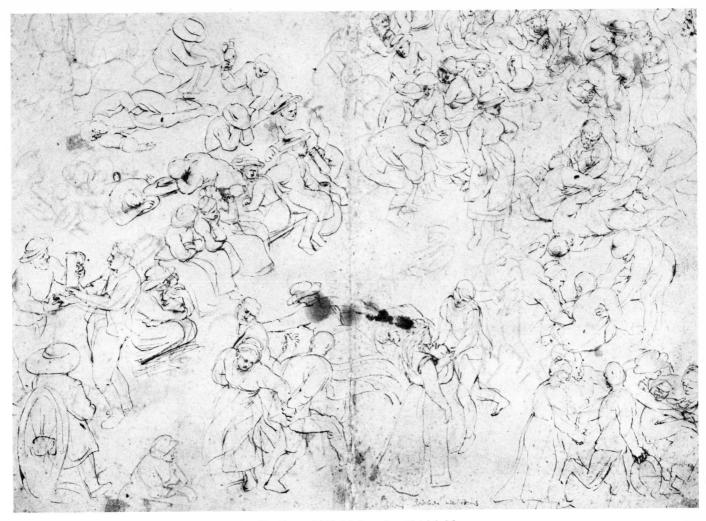

Fig. 5 STUDIES FOR A KERMESSE (detail). About 1629-32. London, British Museum

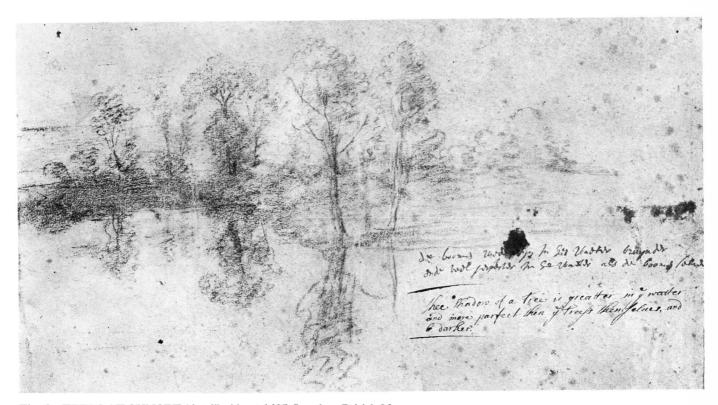

Fig. 6 TREES AT SUNSET (detail). About 1635. London, British Museum

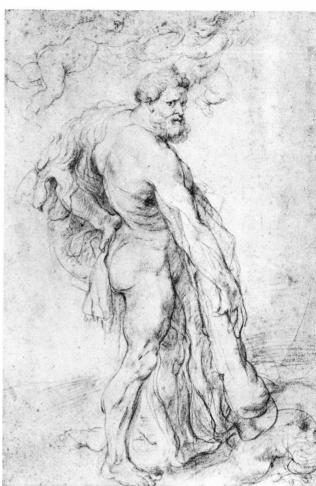

Fig. 7 IGNUDO (after Michelangelo). London, British Museum

Fig. 8 HERCULES. London, British Museum

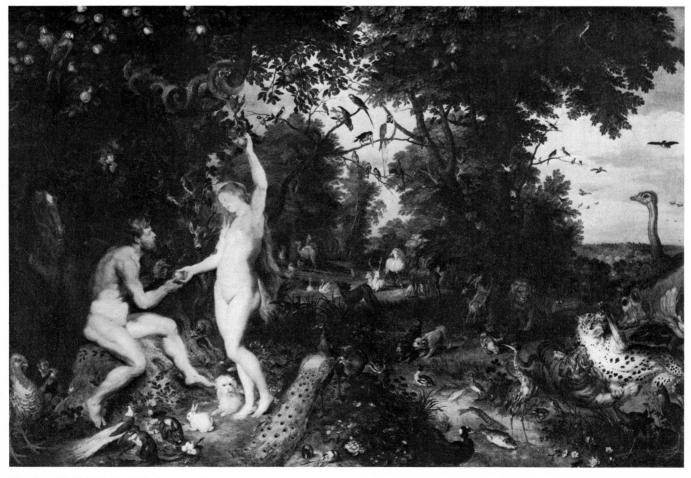

Fig. 9 ADAM AND EVE IN PARADISE (in collaboration with Jan Brueghel). About 1620. The Hague, Mauritshuis

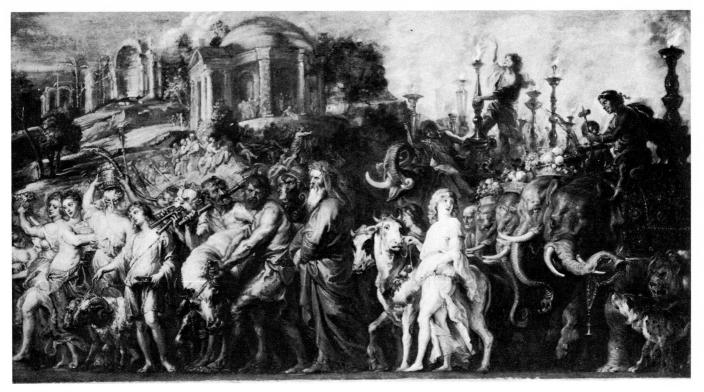

Fig. 10 THE TRIUMPH OF CAESAR (after Mantegna). London, National Gallery

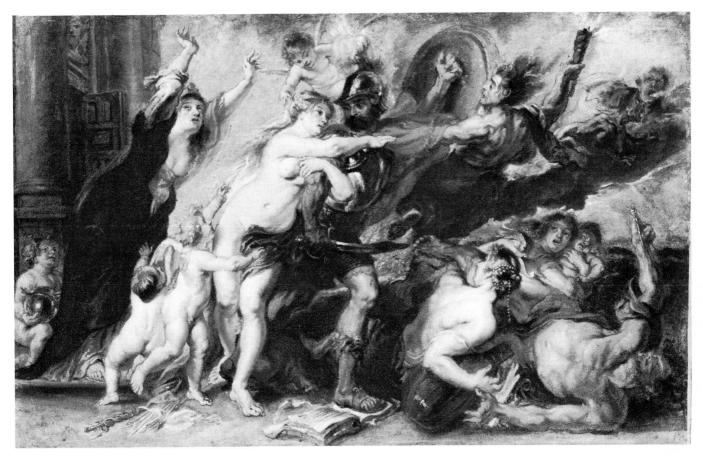

Fig. 11 THE HORRORS OF WAR. London, National Gallery

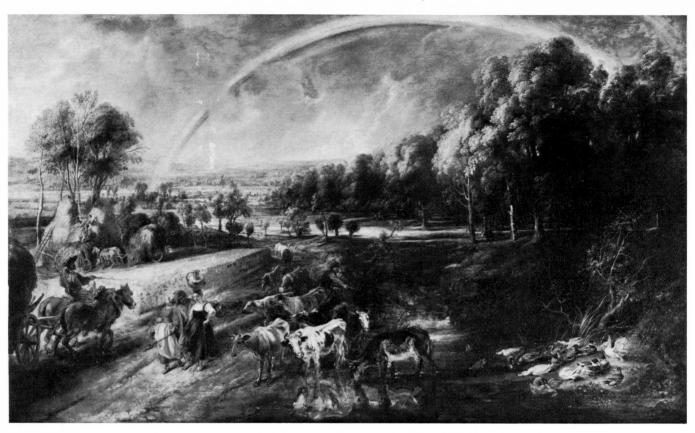

Fig. 12 LANDSCAPE WITH A RAINBOW. After 1635. London, The Wallace Collection

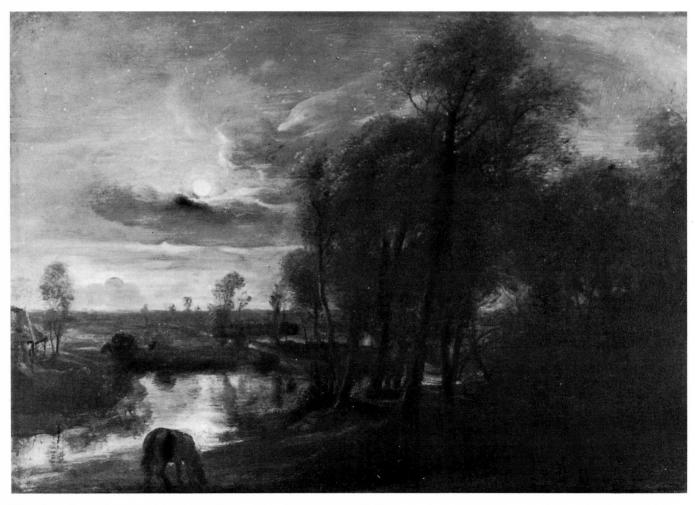

Fig. 13 A MOONLIGHT LANDSCAPE. London, Count Antoine Seilern

Genoese portraits provided a brilliant starting point for Van Dyck but the picture of Brigida Spinola-Doria is also prophetic of Rubens' later work: In it he has hit upon his ideal female expression. Critics have frequently pointed out that all Rubens' women look remarkably alike. This is a roundabout way of admitting a simple fact. A man will often feel a genuine compulsion to reproduce his own particular feminine ideal. In Rubens' case it is not only an ideal appearance but an ideal response. Rubens' women are united by their smile; and this can be hesitant, openly provocative or purely sociable. Rubens' approach to Court portraiture differed radically from that of Van Dyck. Van Dyck was temperamentally addicted to high society while Rubens deliberately chose not to live at Court or to marry into the nobility. Van Dyck seems to have identified himself with the social aspirations of his sitters while Rubens' exhausting diplomatic career left him with a healthy respect for certain outstanding individuals but a rather jaded view of the whole social group. Both Rubens and Van Dyck accepted the courtier's right to visual magnification but both worked with different forms of flattery. If Rubens intends to flatter he does so very openly. A woman's mouth can be minute while her eyes can be huge.

The Duke of Buckingham, whose likeness is preserved in numerous portraits by Honthorst, Cornelius Jonson and Mytens, was famous for his languid, rather effeminate beauty but Rubens chose to celebrate his power through a feat of equestrian mastery and by inbuilt allusions to his career as Commander of the Navy, and Governor of Dover Castle. In this picture (Fig. 4) we can see an important stylistic connection between Rubens' portraits and his other commissions. The Buckingham is an expanded portrait, a picture that is growing into a history painting. Rubens employs all those tricks that he had learnt while working on his recently completed Marie de' Medici cycle. We feel Rubens angling the commission in the direction of his own interests, and it could be argued that the naked sea Gods are too obtrusive. This portrait makes us realise how difficult it is to strike an exact balance between the idea that glorified and the details that identify the man – a dichotomy that is at the heart of seventeenth century portraiture.

Rubens' best portraits are of sitters whom he knew well and whose intellectual interests he shared. When he painted male friends like Nonnius, a Doctor of Medicine, he concentrated on a speaking likeness, on creating an impression of instantaneous movement (Plates 22 and 24). Nonnius, like Rembrandt's Doctor Anslo and Bernini's Scipione Borghese, addresses an audience. He is inviting us to argue. His book falls out of the picture towards us but tantalisingly we are not allowed to read his text. In this portrait the sitter's head is relatively small but our attention is drawn irresistably towards it by the large bust of Hippocrates, the hero of classical medicine, on one side and the shelf of reference books on the other. The marble bust, as so often in Rubens, is painted softly; it is over-animated and we are made to see a strong visual simile between the bust, displaced from its niche, and the head of the living doctor, the modern incarnation of the antique ideal that has taken its place.

In the sixteenth century collectors amused themselves by projecting family likenesses into their favourite busts of Roman emperors, and in the seventeenth century this idea seems to have been taken even more literally. Artists like Bernini even went so far as to adjust a sitter's features in favour of a classical prototype. Since Louis XIV was often compared to Alexander the Great, why shouldn't he also be made a little like Alexander? Hélène Fourment, in contemporary costume, sitting in a modern armchair (Plate 28)

has a face which is far less Venus-like in its proportions than that of Hélène Fourment half-naked wrapped up in a fur coat (Plate 30). Seventeenth century portraits are far more specific than those painted in the sixteenth century. We can measure the difference in approach by comparing Rubens' copy of Raphael's *Castiglione* with the original. Looking at the Raphael, it is hard to gauge the sitter's state of mind; while in Rubens' version he looks frankly worried. High Renaissance repose, simplification and intuitive symmetry, have broken down and been transformed into an emotional, Baroque statement. The sixteenth-century head looks almost blank beside the seventeenth-century painting. The force of the feeling has spilled over into the background: the head is haloed in light and the once smooth contour has become agitated, discontinuous and jagged.

Looking again at the Nonnius we see that Rubens is the master of externalised feeling. His physiognomic range is far narrower than Rembrandt's for he is mainly interested in social expressions, in what can be seen rather than in what can only be implied. The Nonnius bears all the hall-marks of the Rubensian treatment: the nostrils - that moving breathing part of the face that becomes so important in seventeenth-century portraiture – are enlarged and painted as though seen slightly from below. Typical of Rubens are the double scarlet lines that rim the eye, the echoing of the shape of the ear in the rhythm of the swirling hair, and the overstrong highlight on the nose. In this portrait Rubens has rejected completely the Renaissance ideal of balancing halves, of unity acquired by repetition of evenly measured units, and even the idea of a neutral flesh tint. Instead, each feature is rhythmically connected to the next by curving strokes and lines. If we compare a portrait like this with one by Van Dyck, whose portraiture was based on Rubens' example, we shall immediately see startling differences. In Van Dyck's picture of Cornelius van der Geest (London, National Gallery) the Rubensian red line has been replaced by a trail of liquid white. The brushstrokes are still visible in the face, but they are slacker and spread out more independently over the surface. There is a suggestion of indulgence in an overall pattern for its own sake, whereas Rubens allows the strokes to follow more exactly the contours of the forms. The result is a vital intellectual Nonnius and a pensive melancholy van der Geest. Each artist achieves his own ideal expression, which grows quite naturally out of an instinctive, highly personal form of pictorial calligraphy.

FAMILY PORTRAITS

Rubens was not obsessively interested in his own appearance. His self-portraits are straightforward, and they are devoid of that narcissistic element that is so disturbing in the self-portraits by the young Van Dyck. Unlike Rembrandt, Rubens did not use his own features as a basis for studies in physiognomic expression. When he paints himself, it is usually to document some significant event in his life, or in response to a request from an important patron. In 1623, for example, Rubens was commissioned to paint a self-portrait that was presented to the future Charles I, then Prince of Wales (now at Windsor Castle). In the seventeenth century the rising social status of artists is reflected in a general increase in fancy self-portraits and the subject of several paintings becomes the creative act itself. In *Las Meninas*, Velazquez painted himself at work on a group portrait surrounded by those courtiers and dwarfs who had provided the raw material

for so much of his life's work; in several portraits, Rembrandt depicts himself brush in hand; even Vermeer allows us to look over the shoulder of an artist painting from his model. Rubens never paints himself as an artist, but always as a gentleman, enjoying the *status* that he had achieved by virtue of his artistic talent (Plates 5 and 29).

In 1609, when he had just accepted the post of Painter to the Court in Brussels, and at a time when he had committed himself to a future involving much official imagery, he produced one of the greatest autobiographical pictures of the seventeenth century. He painted himself and his new wife Isabella Brant sitting beneath a honeysuckle arbour (Plate 5). In this portrait, Rubens was bent upon finding a pictorial solution that could be completely dissociated from the formality of court portraiture; one that could contain his personal feelings; and yet one in which those feelings could be publicised and magnified by traditional associations with the theme of love.

In working out his design and conception, Rubens was influenced by representations of courtly gardens of love, a vernacular theme common in sixteenth-century Flemish art. He set the scene for his own marriage-portrait in the context of aristocratic relaxation, and his picture becomes a great close-up, a brilliantly expanded detail from one of these garden scenes. In this particular context, Rubens' floral symbolism and the almost archaic gesture of the finger pointing to Isabella's ring do not seem out of place. Like the aristocrats who play in these gardens, Rubens and Isabella Brant are dressed in the most fashionable and expensive clothes. This element might have been difficult to control, and the painting could so easily have degenerated into an ostentatious fashion-plate, but Rubens avoids this pitfall through brilliant 'cutting'. Isabella's 'humility' position on the ground is counter-balanced by the height of her tall hat, but Rubens avoids a repetition of this form by cutting off his own hat just above the brim.

This is a picture with a meaning and the idea of unity in marriage is built into the composition. The external contours of the forms are swept into the circular movement of the design. Isabella's arm rhymes visually with Rubens' leg; his foot is covered by her dress and the close physical association of these parts is echoed, at the very centre of the painting, in the way her hand is placed gently on the top of her husband's. This interrelationship of forms is reinforced by the colour. The two figures are dressed to match, and here we feel that Rubens has indulged in the glory of individual colours for their own sake. The plums, blacks, orange and blue are allowed an independent visual status, and are not swept into those swift relationships of broken tone that are so common a feature of the later paintings, and which are largely achieved by the visible direction of Rubens' brush stroke. This painting is complex in another way as well. Few self-portraits, surely, have ever been so successfully camouflaged. There is none of the awkward angling of the head so often visible in pictures artists paint of themselves. Rubens looks out as though he were confronting some anonymous portrait painter, and it is only by accident that we know that he is facing himself.

In 1630 Rubens married Hélène Fourment, a silk merchant's daughter. She was related to his first wife and was only sixteen. Rubens was well over fifty and in a letter to a friend confessed that he was tired of celibacy. He points out that he could have married a lady of the court but had deliberately chosen a middle-class wife, 'one who would not blush to see me take my brushes in my hand.' Whilst it would be too crude to suppose that Rubens married for a model it is true that he became visually infatuated with his new wife, who enjoyed a contemporary reputation as a great beauty. Hélène Fourment's face and body recur in all categories of his art. She became an all-pervading common

denominator in his work, and around her features the middle-aged artist was able to generate new fantasies. Rubens had retired from his diplomatic career and had begun to paint more and more for his own pleasure. He had always enjoyed painting his children and had frequently used them as models for cupids and cherubim. He painted them in very much the same spirit as a modern father might constantly re-photograph his children. In the Munich portrait of Hèléne Fourment, and again in the Louvre picture (Plate 45), he produced frankly appealing, almost sentimental paintings.

On his death, Rubens left his wife a painting, a portrait of herself in the nude draped in a fur coat (Plate 30). Art historians have been unnecessarily pedantic about this picture. Does it really matter if she is a Venus or a Bathsheba, whether she has just taken or is about to have a bath? Whilst we must admit that Rubens had a certain range of associations hovering in his mind, these need not necessarily have been settled on any one specific subject. When Rubens paints a Venus or Bathsheba he usually leaves us in no doubt of the fact. Rubens' preliminary drawing for the painting shows Hélène sitting down and the uncharacteristic, though not unbeautiful lengthening of her legs in the painting may indicate a certain amount of hesitancy on the artist's part as to the final pictorial identity of the figure. Rubens sees Hélène Fourment through memories of the Titian's Girl with a Fur (Vienna), of which he had made a replica, and which in the seventeenth century was thought of as an image of a prostitute or mistress. It may be significant that he had it at the back of his mind when producing his own portrait of his favourite model. Rembrandt had followed a very similar procedure when he painted, his wife, Saskia, as the goddess of flowers after seeing Titian's Flora in an Amsterdam sale room.

Rubens could think of Hélène in many different roles and it is only in his paintings of her that he really exposes himself. During his diplomatic career Rubens had often been snubbed and insulted by aristocrats. In 1630 he had failed to gain the post of envoy to the court in London because it was claimed that he 'practised an art and lived by the product of his work.' It is, therefore, interesting to see him in the Munich 'wedding-portrait' of this time (Plates 25 and 28) representing his middle-class wife with all the glory of the court-portrait formula. We have the armchair pose, the magnificent costume, the columns and curtains, all those ingredients which he combined in his early Genoese portraits of the seated Brigida Spinola-Doria (Fig. 3). In the Munich picture the whole mechanism is turned inside out and our preconceived ideas of decorum are destroyed. The strict relationship between the figure and its setting is broken: the armchair is tilted and the life of the figure throbs into the background. The violets, silvers and blacks sparkle like anthracite; the curtain behind Hélène is arbitrarily dissolved, and gives way to an evocation of moving clouds and open air.

We should now look from the face of Hélène in her sumptuous dress (Plate 28) to the Hélène who wears the fur wrap. And if we look carefully, we can see Rubens adjusting her already idealised features in favour of a Venetian version of a classical goddess. The alterations are subtle and not easy to isolate, though we can see that the chin is rounded, the eyes are enlarged and the spacing widened. The hair is longer and disarranged, divorced from associations with contemporary fashion. The eyebrows have new emphasis and are smoothed into a Titianesque crescent. The ribbon around her head, a kind of seventeenth-century 'vamp-band', and the tension of the ear-rings, hint at an exciting exoticism. The inviting smile has evaporated, to be replaced by a far more enigmatic and less focused gaze. This is a deliberately ambiguous picture. The hand on breast –

that traditional classical gesture of modesty – has become instead one of exposure. By subtle, indefinable means, Rubens manages to hold our attention exactly half-way between the woman and the woman transformed into the subject of a picture.

The Hélène Fourment in a Fur Wrap is Rubens' credo. It illustrates his belief in art addressed to the senses, his method of working from objects rather than ideas. In 1625, when Rubens was working on his Marie de' Medici cycle, he needed models for the sirens who appear in the foreground of the Queen's disembarkation (Plate 18). He wrote to a friend asking him to book the services of three sisters who lived in Brussels. He claimed that he needed these three in particular because of their beautiful bodies, expressive faces and magnificent black hair. Most seventeenth-century painters would have worked up three figures from one model.

This picture is an exceptional example of Rubens' art, and it soars above the normally very high standard of his autograph work. Here he paints tenderly, softly, almost tentatively, with a touch that is less fluent, less premeditated or schematized than in many of his mythological paintings of nudes. On this occasion Hélène does not have to accept the apple from Paris or, disguised as a Sabine, struggle with a Roman soldier. She just has to stand still and let herself become the subject. This is Rubens expressing beauty in art through the object that he felt was most beautiful in life. Looking at Hélène Fourment, draped in furs, we can sense that Rubens could never have made art out of the accidental, that – unlike Rembrandt – he could never have painted models resting from the pose or found beauty in what was, and is, conventionally ugly.

THE LANDSCAPES

It is not easy to find out how contemporaries reacted to Rubens' landscapes, since he seems to have kept most of them to himself. Even when we can identify a patron it is not particularly helpful for Rubens was never a landscape specialist, producing pictures to order, but an artist who tackled the subject sporadically, emotionally, and primarily for his own pleasure. The Dresden Boar Hunt (Plate 12) bought by the Duke of Buckingham in 1627, was originally painted for the large hall in Rubens' own Antwerp house. It is not known whether the pair of small landscapes of a Morning and Evening, also at York House, were specially commissioned by the Duke, but they are important for they show that Rubens was producing 'Times of the Day' landscapes in the 1620s. The trend away from paintings celebrating seasonal activities towards the rendering of specific light effects, the identification of subjects by light rather than labour, is general in the first half of the seventeenth century. This change had been pioneered by Rubens' acquaintance Adam Elsheimer, whose small painting on copper representing the dawn was famous in Rome. It is significant that Edward Norgate, writing on miniature painting in the 1640s, should state quite dogmatically 'the best and most pleasing kind of landscapes are those representing the morning and evening. For a rising or setting sun affords such variety and beauty of colours . . . for cloudy skies and menacing weather take up as much time as the other, yet are nothing so pleasant'.

Norgate's taste had been formed on Rubens' work, which included storms, but what he says does seem to have a real connection with landscape painting generally in the 1630s when, simultaneously in Italy and in Northern Europe, landscape began to look less obviously composed and dramatic. Artists began to paint the sun. Caravaggio's tonality,

so long associated with night scenes, is on the way out and Rubens tries to match the brightness of real daylight with strong directional painting, using bright colour and pigments which are very different from each other in texture. In the 1630s, more gradually and using a very different technique, Claude paints the sun reflected in the sea. At the same time artists began to paint from nature; and we find Rubens making coloured chalk sketches and painting on small wooden panels out of doors. He told Edward Norgate that he had painted his dawn landscape from nature but had 'adjusted it a little'. In the Rainbow Landscape (Fig. 12 and Plate 41), he celebrates the triumph of his new tonality. A peasant woman lifts a brass ewer against the corn, gold glows against gold, and yet the spatial definition is precise and perfect. At the beginning of the century artists had assembled their landscapes from stylized black and white drawings and motives drawn from older engravings. Conventions of stylization were so strong that the critic Van Mander jokingly claimed that the real stunted Netherlandish trees had begun to grow exactly like those in contemporary paintings. Landscape then had a very fragile contact with real nature and Rubens' great originality lay in his effort to preserve an account of what it is like to be, and to see colour, out of doors. The sunlit pictures of the 1630s, Claude's harbour scenes, Rubens' sunset meadows, cannot be explained away by any revolution in public taste. They depend on a gradual accumulation of skill on the part of artists, and a gradual elimination of artificial props needed to sustain the perspective illusion. It is even possible that as construction became less difficult and less obvious, subject matter became correspondingly less dramatic and the usual rather than the exceptional in nature became a more frequent theme for landscape painters.

At first Rubens accepted the early seventeenth-century view that landscape was an area for specialists. It was felt that an elaborately developed landscape, packed with botanical and zoological detail, gave the patron a splendid visual bonus. Rubens' Adam and Eve (Fig. 9) with its landscape by Jan Brueghel was painted on this assumption at a time when Rubens was aggressively ambitious and out to attract influential patrons. In recommending his Abraham dismissing Hagar to Sir Dudley Carleton in 1618, Rubens tells him that he has engaged an expert to paint in the landscape 'solely to augment your Excellency's pleasure'. 'Pleasure' is the key word here; and some seventeenth-century theorists, like Rubens' admirer Roger de Piles, believed that landscapes were not only pleasant to look at, but equally pleasant and relaxing to paint. At this time landscapes still had no coherent theory, its propagandists were Northerners and it came low in the hierarchy of the genres. It was not considered so useful as a portrait nor so edifying as an altarpiece; but in practice it was a popular and expanding area. The unofficial upgrading of this genre lay not in developments in seventeenth century art theory, which were tightly bound up with moral preoccupations, but in the sheer brilliance of the contribution made by great artists: Annibale Carracci, Domenichino, Claude and Rubens himself.

Of all seventeenth-century landscape painting, Rubens' work alone gives us the temporary illusion of being outside. His landscapes are hard to write about, for the principles on which they are constructed are not particularly obvious or predictable. Rubens was not a specialist and his landscapes are not so inbred as those painted by Claude. He does not refine his ideas gradually from picture to picture but by a series of remarkable leaps and bounds brings us into an area not developed further until the nineteenth century. The *Château de Steen* (Plates 37, 38 and 40) and the *Rainbow Landscape* revolve around

rather ordinary objects, wattle fences, cows, haystacks and milkmaids, a horse and cart, a huntsman and his dog, the whole paraphernalia of rural domesticity. Rubens' late landscapes are much more than just a tribute to the natural scene: they are frankly triumphal, a celebration of Rubens' own control over the complexity and abundant variety of nature.

As we look at these extraordinary paintings, we can sense an artist working for himself, feeling his way around countryside in which he lived and knew well. Unlike most contemporary landscape painters, Rubens saw brilliant colour in details as well as in larger parts; and for him nature was always in movement, filled with conflicting directions. He aims to share with us the excitement of an exploration and he gives us more to look at per square inch than any other landscapist. He is not inviting us to rest our eyes and minds, with soothing passages of scenery; but teaching us how to see. Placed beside the work of his contemporaries, Rubens' landscapes look almost under-composed, the constructional element being revealed in the ripple of the brush-strokes rather than through the selection of motives. Rubens early landscapes reveal his deep familiarity with the work of local Antwerp painters like Jan Brueghel and Gillis van Coninxloo. His woodland paintings, even the backgrounds of subject pictures like The Boar Hunt (Plate 12), have the same heaped-up rhythmic quality, the same exaggeration of the 'accidental' in nature. Rubens responded to the density of their detail and went out with a sketchbook to make his own glossary of nature, his own studies of fallen trees and blackberry bushes.

Armed with this accumulation of detail, he achieved – almost accidentally – a comparable, though less forced, mood of menace. Rubens collected northern landscapes, and sincerely admired specialist skill, but he was cut off from other painters by one important fact: he was unable to think or to draw in straight lines. He leads us into his landscapes through sequences of intersecting wedges, forcing us to approach diagonally and not allowing our eyes that gentle horizontal scanning, from one side to the other and back again, that is so relaxing in the work of Claude, and which is a feature of so much seventeenth-century landscape painting. Rubens is reluctant to put a frame around his landscapes, and his motives are not arranged with the edges of the painting constantly in mind. Trees near the edge will lean out of the picture rather than into it; his figures, likewise, walk in and out of the space that he has created for them. His work can make even a Ruisdael or a Claude look flat.

Rubens plays down the division between ground and sky. His landscapes do not reveal a tasteful selection of dominant vertical forms placed against a light sky. In fact, the tonality of his landscapes does not depend on the colour modulations of the sky as do the paintings of the great Dutch specialists like Ruisdael. With Rubens, light is not merely diffused, it is not soaked up into the weave of a canvas, but is often given a vibrant, positive direction. In the Wallace Collection *Rainbow Landscape*, a shaft of light shines into the picture from the front, suggesting to us that the landscape space begins before it actually appears in the painting. Rubens will pull storm light down from the sky by dragging a coarse brush over the wet ground paint of his panels. It is obvious why Rubens avoids a dominating horizon line; it would have stilled his picture and cancelled out his vision of nature as growing and changing and in perpetual conflict. Unlike most of his contemporaries, Rubens was deeply interested in describing the outside edges of objects seen out of doors. When his French friend Peiresc wrote asking him for an essay on colour, Rubens confessed that it was not colour that he found

difficult but contour. Rubens would always extract the maximum life and movement from his contours. The cows in *The Rainbow Landscape* have haloes of silver light, and flashes of scarlet underline their udders. Yellow light will pile up thickly against the outline of twisted tree trunks. Rubens left his technical methods deliberately exposed, realizing that a sense of speedy execution can help to create the impression of nature glimpsed, so to say, in passing. Constable, who learnt more from Rubens than from any other painter, was right when he pointed out that the rainbow was the clue to Rubens' attitude towards nature. The rainbow concentrates light revealed as colour and it symbolises a scarcely resolved conflict between storm and sunlight. It is the essence of the spectacular and of what is unstable – and it is, of course, a curve with an arc that breaks the tranquil area of the sky. Its colour can be spread over a landscape, either naturally by reflection, or by calculation, with the colours repeated in the clothing of the peasants in the fields below.

In Rubens' landscapes no holds are barred. He will even attract real light into his picture. It will hit the three-dimensional red berries in the foreground of the Château de Steen or the curled edge of a water-lily leaf in the Rainbow Landscape. Even in the fragile area of atmospheric perspective he will suddenly prefer an effect of almost incongruous solidity, painting the sun as a lump of burnished impasto. In the Moonlight Landscape (Fig. 13) the stars have all the literalness of a quattrocento ceiling, they are raised points of white paint. Rubens will try to make tangible even the intangible. In the Sunset Landscape (Plate 46) the sun slices the horizon; its light is not purely space creating for it exists in its own right as an object in space. Rubens' recession always depends heavily on the scale of his trees and bushes. He is reluctant to 'fade out' and in The Watering Place (London, National Gallery) minute trees on the skyline are accentuated by being framed in the forked trunk of a foreground tree. Even in Rubens' late landscapes, with their softer painting and creamier colours, we are granted supernatural sight, we see further than we should and hover in a visionary position above the foreground. In finished pictures, Rubens was never quite able to abandon the old sixteenth century ideal of a world landscape.

It is not easy to define the difference between Rubens early and late landscapes. The late works have a new lyricism and an increased softness. Recession depends less on the alignment of objects and more on the direction of the brush strokes. In his early work we might feel that Rubens was imposing on landscape an idea of energy that he had first elaborated in figure paintings. In the late work trees grow like trees and behave less like the fallen heroes in some mythological work. Space takes on a new importance for the mature Rubens and he begins to set more and more subjects out of doors. The mood and meaning of a subject picture is reinforced by the landscape background. Those flat landscapes - like that in the Rape of the Daughters of Leucippus (Plate 15) contrasting in scale and almost irrelevant to the subject, drop out of his work. On his late drawings he writes notes reminding himself to give a figure more space. He is now able to project intimate visions into landscapes. In private fantasies he sees the familiar made strange, knights joust on his own estate and lovers play in meadows before moated castles (Plate 47). Rubens becomes fully reconciled to northern art and his knowledge and feelings about the paintings of Pieter Bruegel enter into a new intimate phase. He finds a new delicacy in Bruegel's work and begins to appreciate the delicacy of his touch, the lightly spotted foliage of his trees. He pays a late tribute to his great sixteenth century predecessor in the Kermesse now in the Louvre (Plate 39). The preliminary drawings for

this picture show Rubens deliberately holding down his own rhythms, deliberately striving to build up forms with Bruegel's simple shapes circumscribed by blunt outlines. It is almost as if Rubens, in the 1630s, was trying to destroy the whole concept of a hierarchy of subject matter in painting; the separation between subjects seems to be breaking down in a glorious last release. Landscape is taken towards mythology. Rubens discovers that a certain vagueness in painting can create a very precise yet subjective reaction in the spectator. We can see how far he has travelled if we compare his Cassel Flight into Egypt (Plate 8) with the Moonlight Landscape. In the first, landscape is a by-product of the subject, and its scale is too small for the figures. We are aware of the idea of flight, of figures moving through space. This is a beautiful painting but the mood is Rubens' only by adoption. It properly belongs to Adam Elsheimer and to a smaller format. Here we can sense Rubens' mind at work, we can see him associating Elsheimer with those dark Caravaggesque tones that dominated Italian painting in the first decade of the century. The angel who guides the donkey is lifted straight out of Caravaggio's Martyrdom of St Matthew (Rome, San Luigi dei Francesi). There is something very fragmented in this effort; the source of the idea intrudes on the subject itself. The Seilern Moonlight Landscape began life as a Rest on the Flight into Egypt, but Rubens painted the figures out and turned the subject from a Biblical scene into a pure landscape, extending the space by adding to the panel, and by converting the donkey, crucial to the Flight of the Holy Family, into a mere grazing animal. But the idea of rest remains, it is inherent in every form - in the rather slack angles of the trees, in the meandering line of the stream, and in the silhouette against the illuminated water. The young Rubens had been able to create an ideal of energy but not one of repose. His art became mellow and relaxed in character as he began to face the therapeutic implications and properties of landscape art. His work had been constructed upon the achievements of the sixteenth century; he had borrowed easily identifiable motives but he had tended to see the works of art themselves in isolation. He had been conscious of what the paintings of his predecessors looked like, but only perhaps late in life did he come to understand their full effect. Only then did he grasp the projection of a mood and begin to play in that glorious half-way house somewhere between fact and fantasy. No other painter in the seventeenth century was able to direct landscape into such autobiographical channels, just as no other artist of the period made such a public decision to have so private a life.

Bibliography

Piles, R. de; Conversation sur la Connaissance de la Peinture. Paris, 1677

Rooses, M.; L'oeuvre de P. P. Rubens, 5 volumes. Antwerp, 1886–92

Evers, H. G.; Peter Paul Rubens. Munich, 1942

Glück, G.; Die Landschaften von Peter Paul Rubens, 2nd edition, Vienna, 1945

Puyvelde, L. van; The Sketches of Rubens. London, 1947

Burckhardt, J.; Recollections of Rubens. London, 1950 Magurn, R. S.; The Letters of P. P. Rubens. Cambridge, Mass., 1955 Held, J.; Rubens, Selected Drawings, 2 volumes. London, 1959 Gerson, H. and Terkuile, E. H.; Art and Architecture in Belgium 1600–1800. London, 1960 Fromentin, E.; The Old Masters of Belgium and Holland. New York, 1963 (Introduction by Meyer Schapiro)

Chronology

- 1577 June 28: Rubens born at Siegen, Westphalia.
- 1600–1608 Visited Italy and in 1600 entered the service of Vincenzo Gonzaga of Mantua. Lived at Mantua, Rome and Genoa, where he painted portraits of the nobility (Plate I and Fig. 3).
 - 1603 First visit to Spain on behalf of Vincenzo Gonzaga. Paints the equestrian portrait of the Duke of Lerma, and copies after Titian.
 - 1608 Return to Antwerp.
 - 1609 Rubens appointed painter to the Brussels Court of the Archduke Albert and the Infanta Isabella. Married Isabella Brant.
- 1609–1621 Executed important series of paintings at Antwerp: the Triptych for Antwerp Cathedral (Plate 6); the Tapestries of the History of Decius Mus; the *Peche Miraculeuse* for Mechlin; and paintings for the Church of the Jesuits, Antwerp (Plate 9).
- Visited Paris (1622, 1625) in connection with the *Life of Marie de' Medici* cycle for the Luxembourg Palace (Plate 18). The Tapestries of the History of Constantine.
 - Death of Rubens' first wife, Isabella Brant. Altarpiece of the Assumption in the Antwerp Cathedral. The Achilles Tapestries and the Eucharist Tapestries (Plate 42).
 - 1628 Second visit to Spain, on a diplomatic mission. Painted portraits of Philip IV and the other members of the Royal Family. King Philip appointed him Secretary of the Netherlands Privy Council.
- 1629–1630 Visit to London as envoy to Charles I. Was knighted by the King and given an Hon. M.A. by the University of Cambridge.
 - 1630 Return to Antwerp. Marriage to Hélène Fourment.
- 1630–1634 The Garden of Love; the Saint Ildefonso Altarpiece (Plate 36); paintings for the Whitehall Ceiling.
 - 1635 Purchase of the Château de Steen (Plate 38).
- 1636–1640 Paintings for the Torre de la Parada, Philip IV's Hunting Lodge near Madrid (Plate 35). Painted the most important of his landscapes.
 - 1640 Died May 30. Inventory made of his collections and of paintings remaining in his studio.

Plates

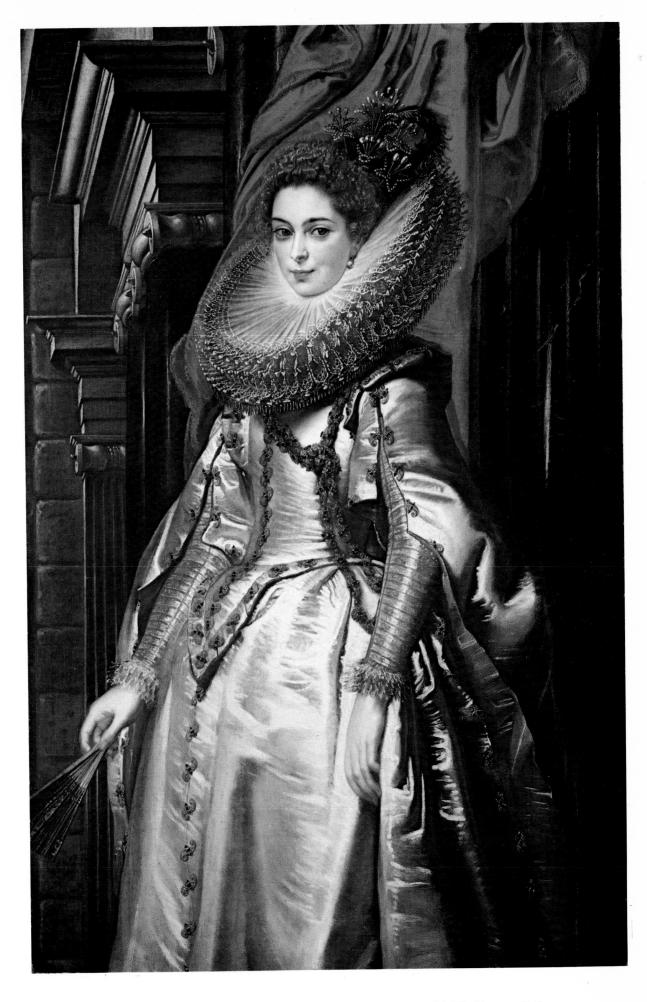

 PORTRAIT OF THE MARCHESA BRIGIDA SPINOLA-DORIA. 1606. Washington, D.C., National Gallery of Art (Samuel H. Kress Collection)

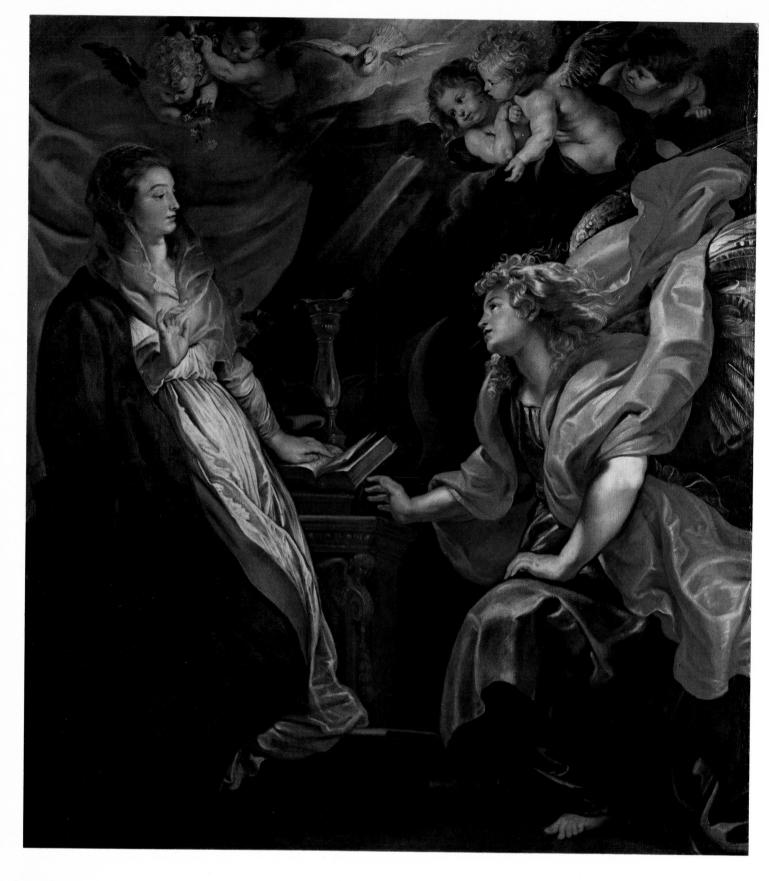

2. THE ANNUNCIATION. About 1609-10. Vienna, Kunsthistorisches Museum

3. THE APOSTLE SIMON. About 1613. Madrid, Prado

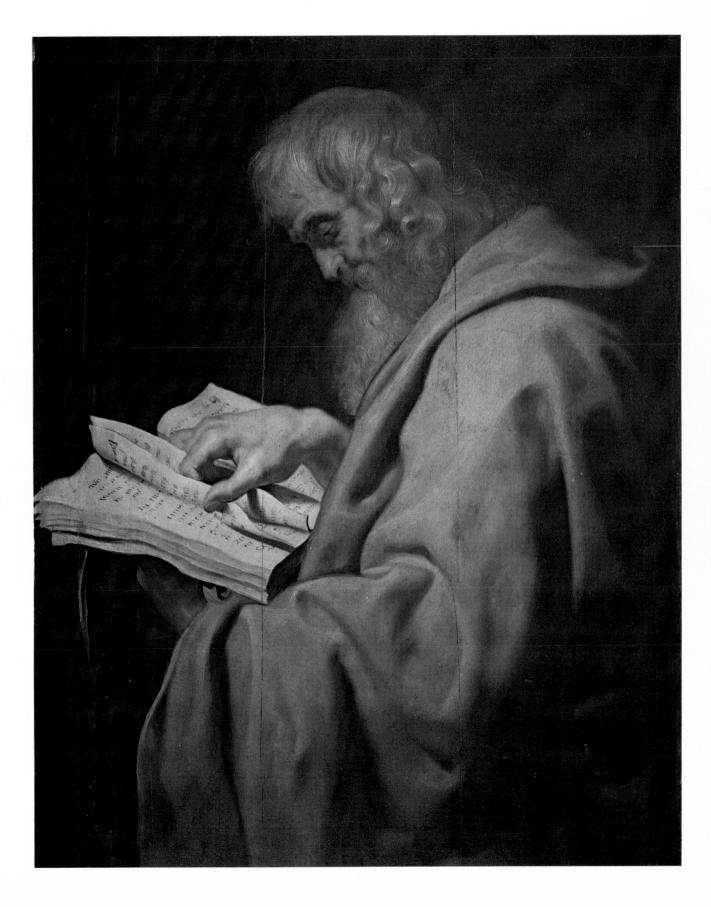

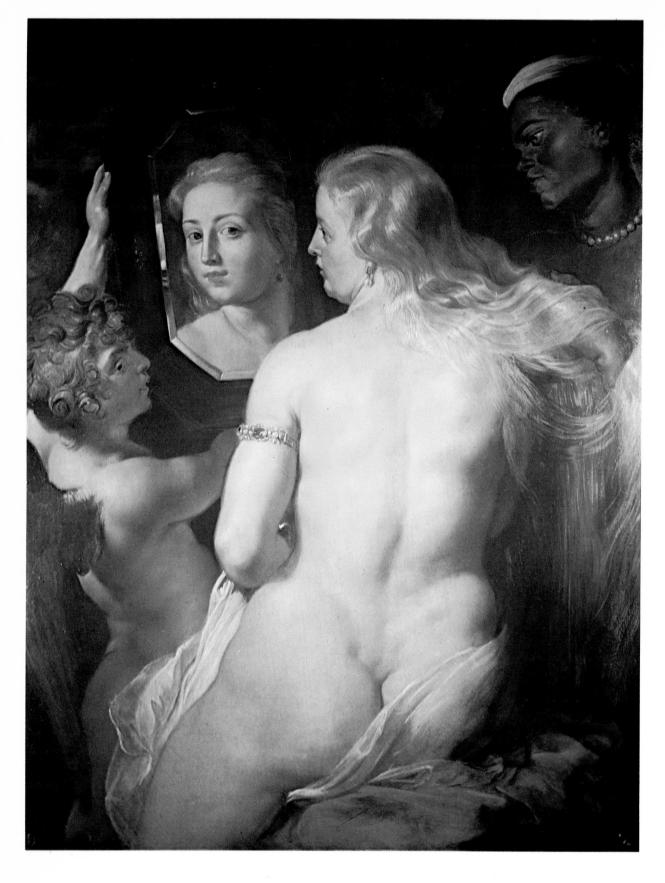

4. THE TOILET OF VENUS. About 1613. Vaduz, Liechtenstein Collection

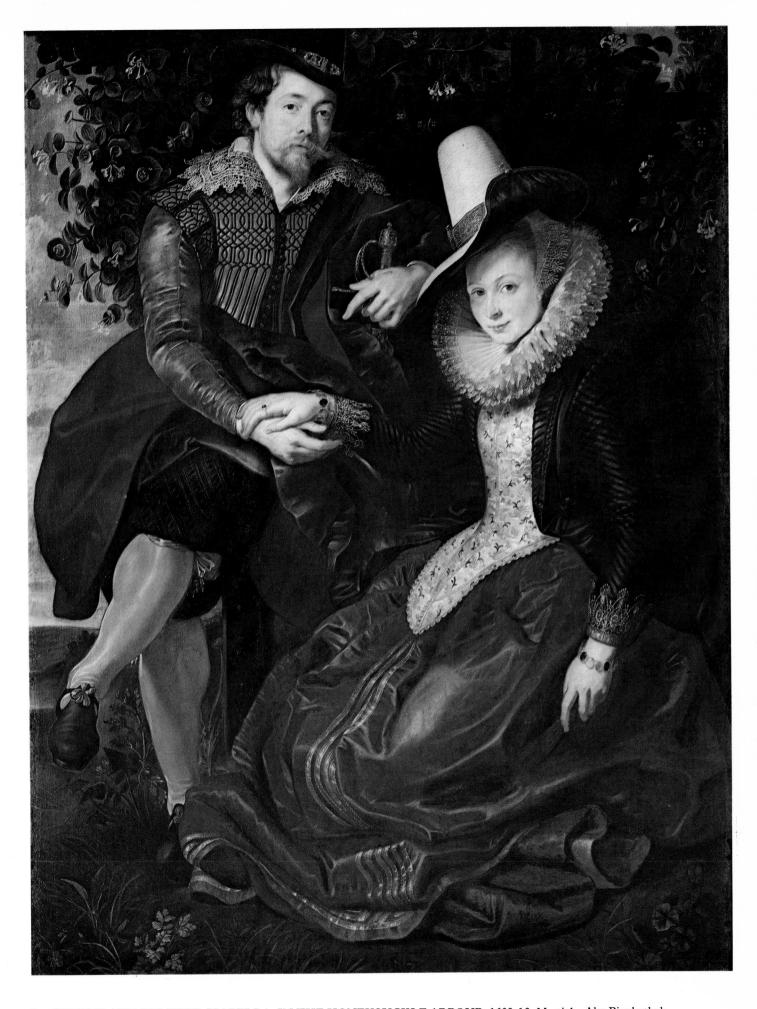

5. RUBENS AND HIS WIFE, ISABELLA, IN THE HONEYSUCKLE ARBOUR. 1609-10. Munich, Alte Pinakothek

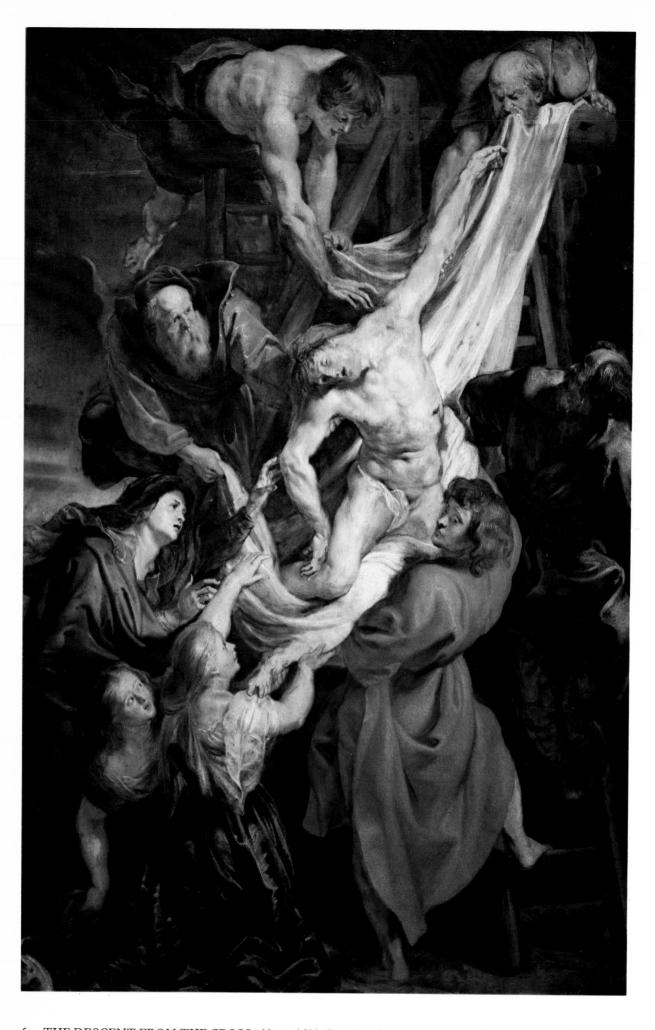

6. THE DESCENT FROM THE CROSS. About 1611. London, Courtauld Institute Galleries

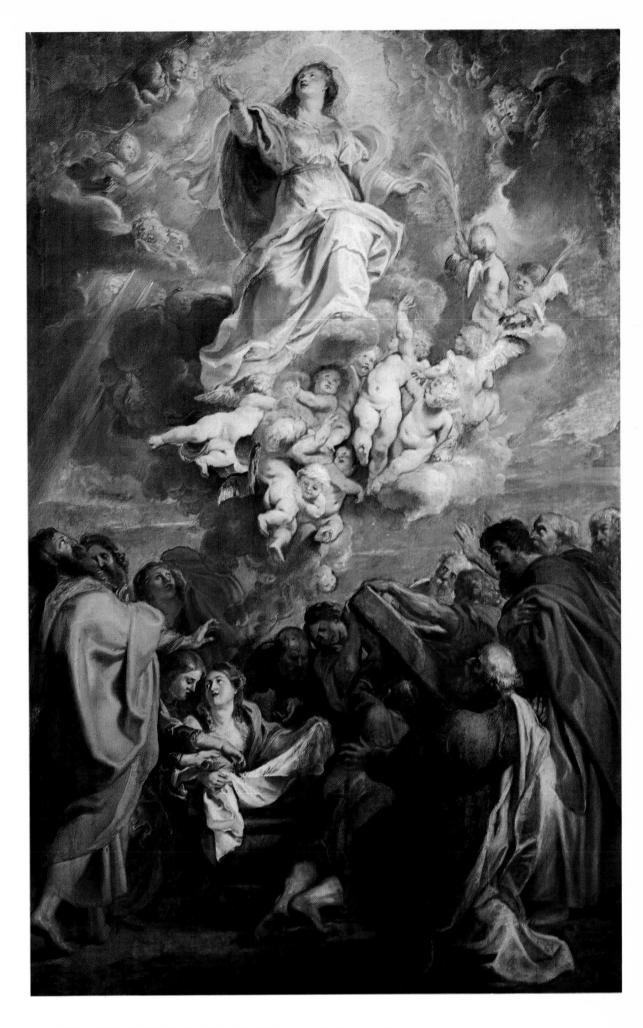

7. THE ASSUMPTION OF THE VIRGIN. 1611-15. London, Buckingham Palace (Reproduced by gracious permission of Her Majesty the Queen)

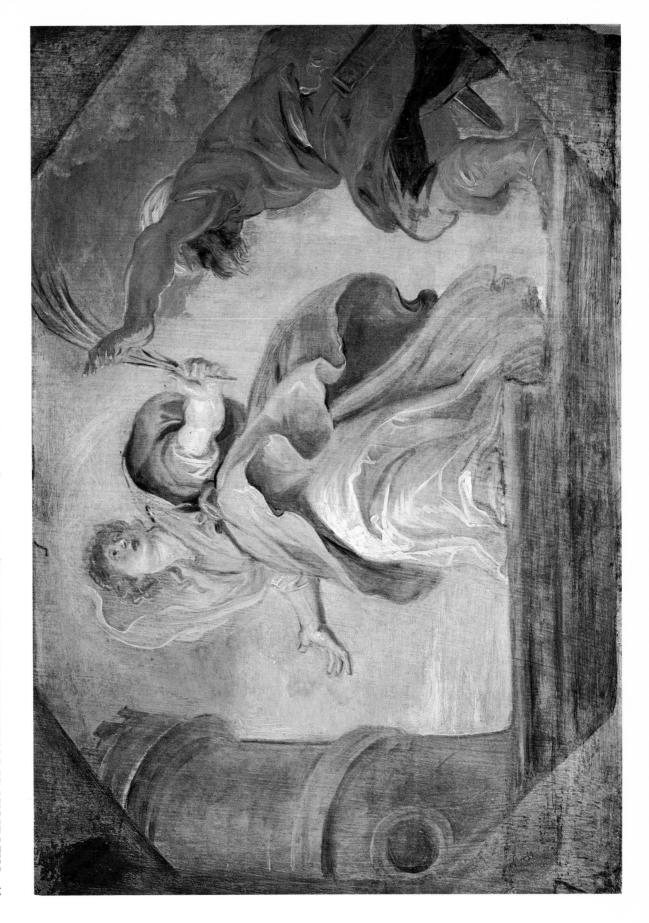

9. THE FLIGHT OF ST. BARBARA. About 1620. London, Dulwich College Gallery

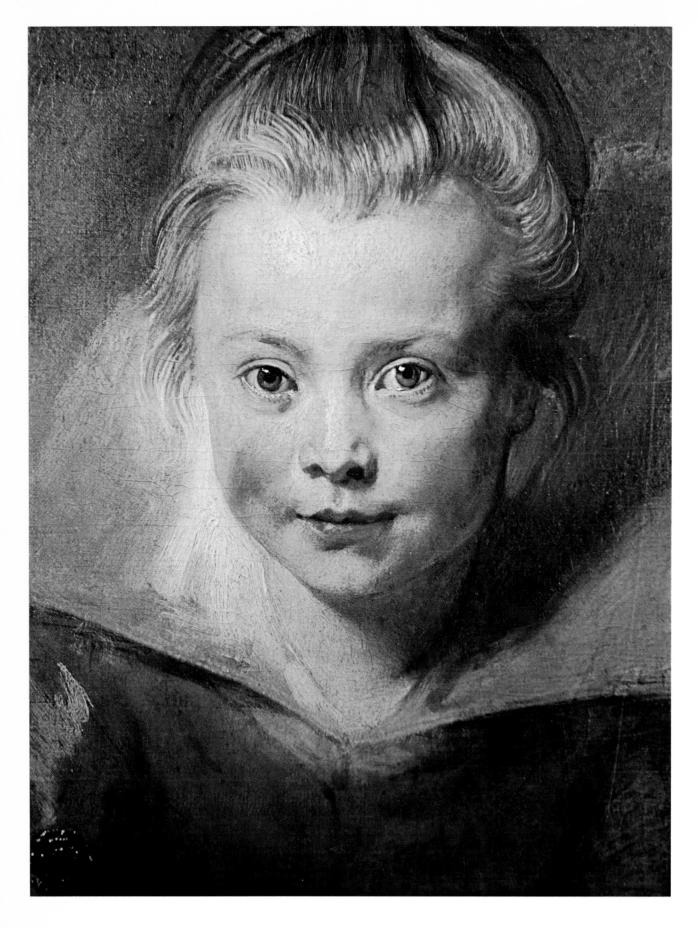

10. HEAD OF A CHILD. About 1617. Vaduz, Liechtenstein Collection

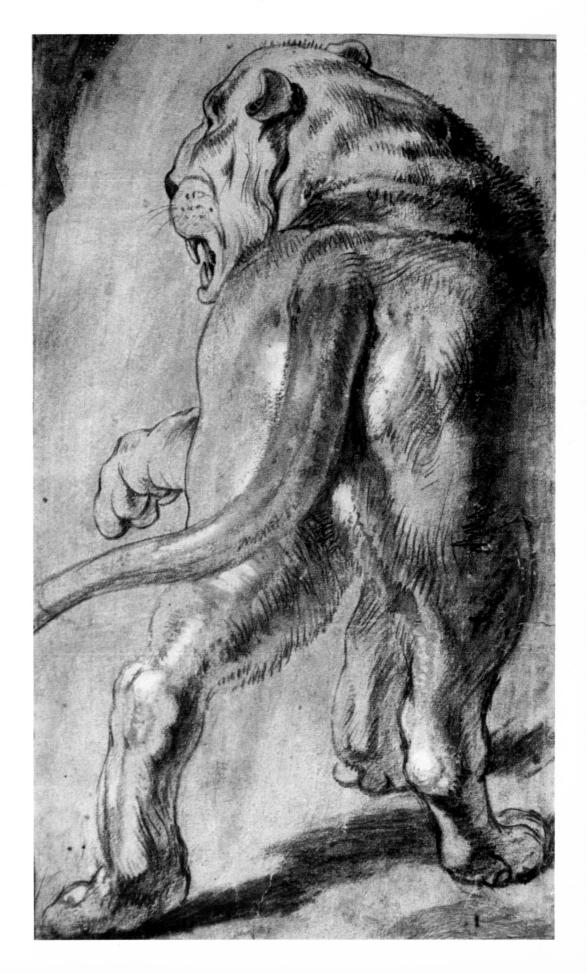

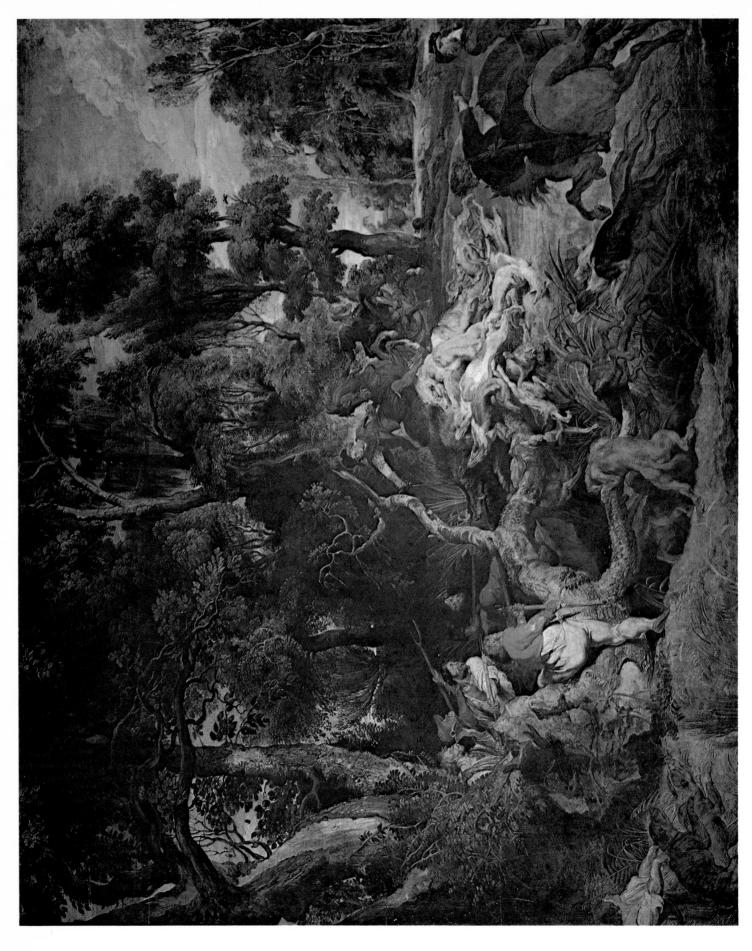

13. THE BATTLE OF THE AMAZONS. About 1618. Munich, Alte Pinakothek

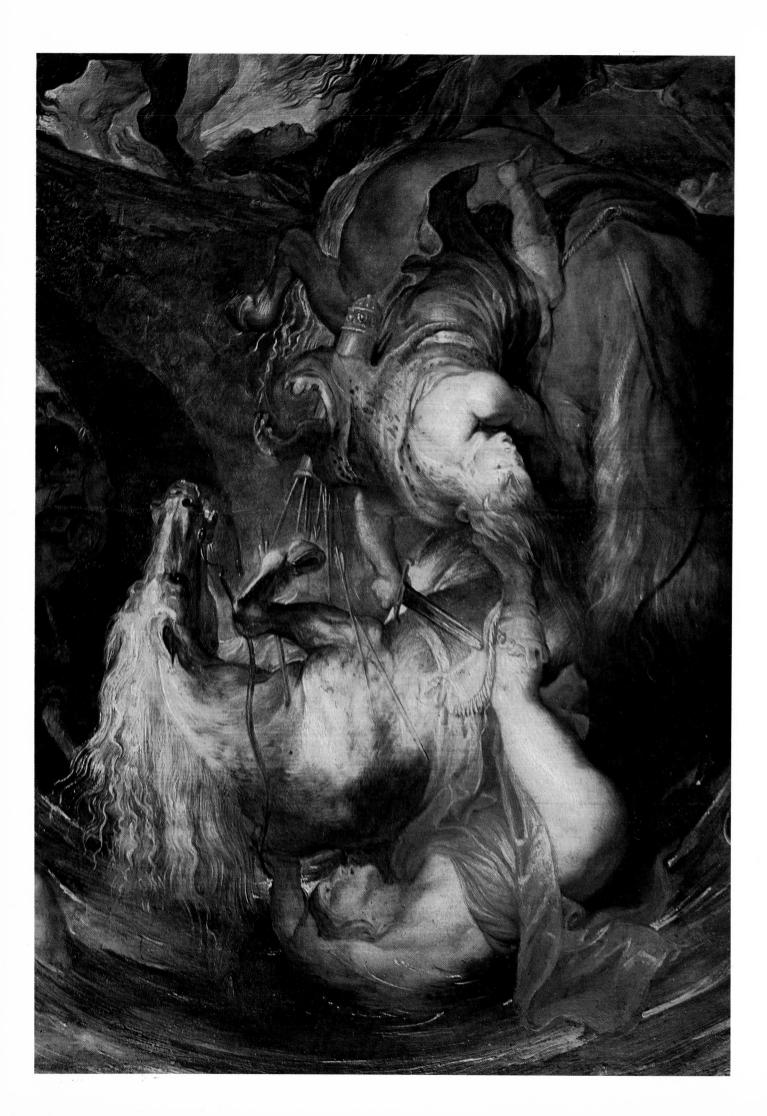

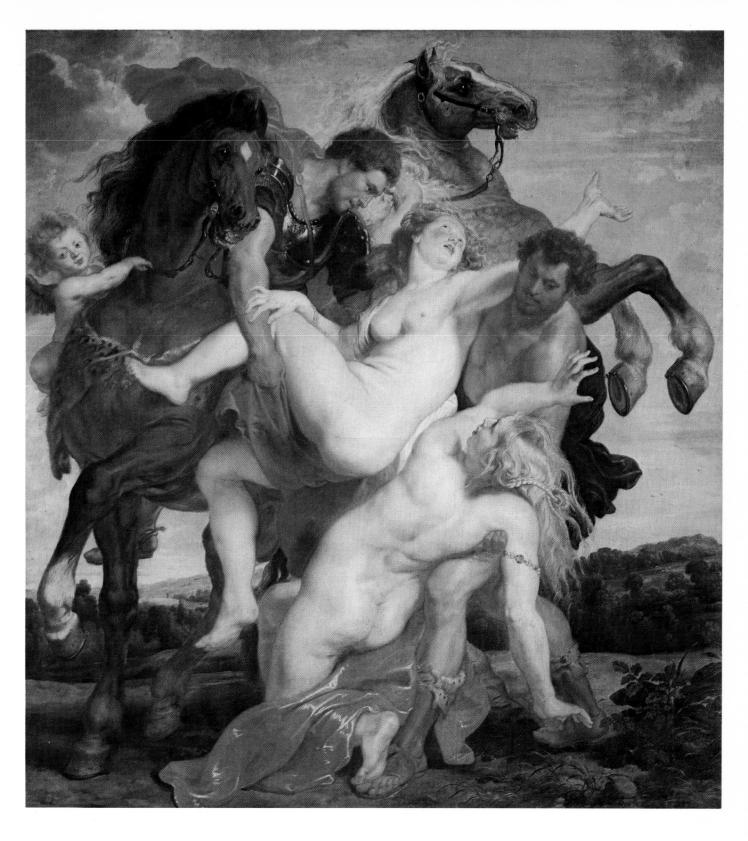

15. THE RAPE OF THE DAUGHTERS OF LEUCIPPUS. About 1618. Munich, Alte Pinakothek

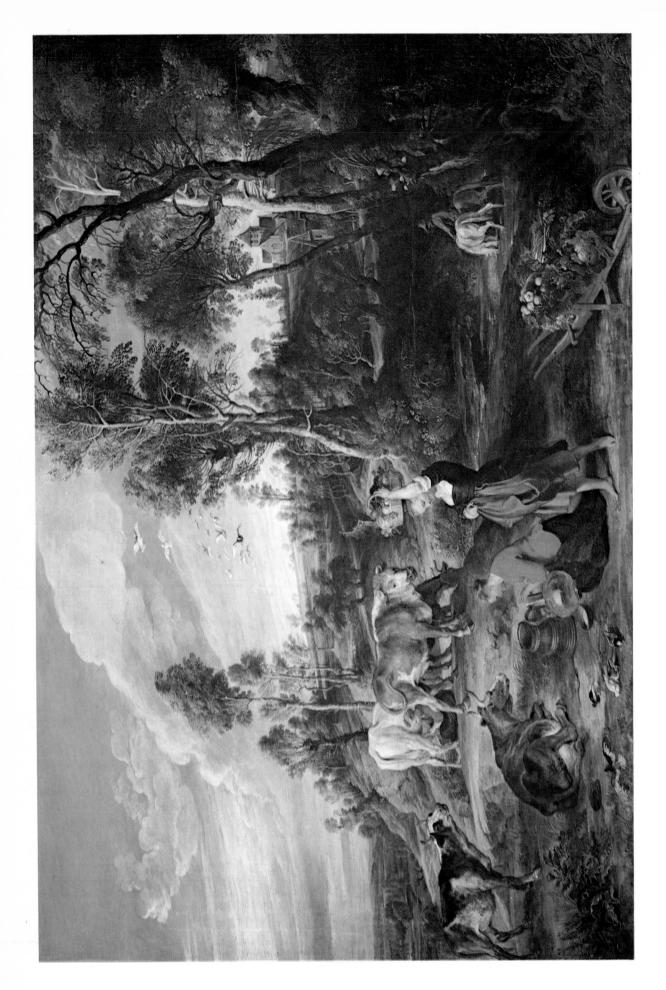

16. THE FARM AT LAEKEN. About 1618. London, Buckingham Palace (Reproduced by gracious permission of Her Majesty the Queen)

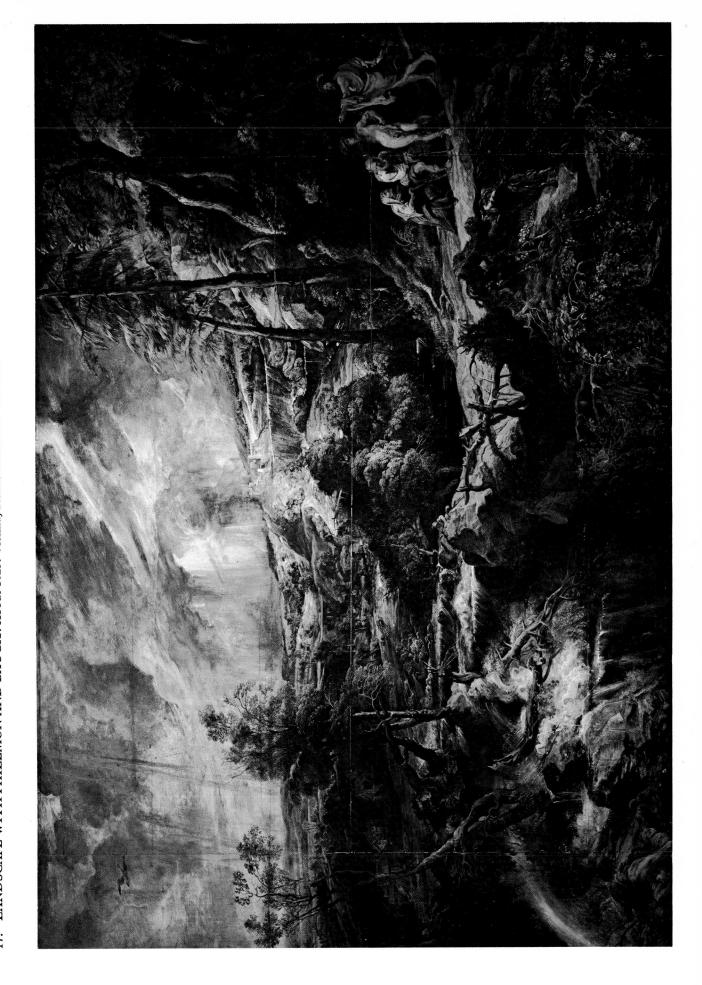

17. LANDSCAPE WITH PHILEMON AND BAUCIS. About 1625. Vienna, Kunsthistorisches Museum

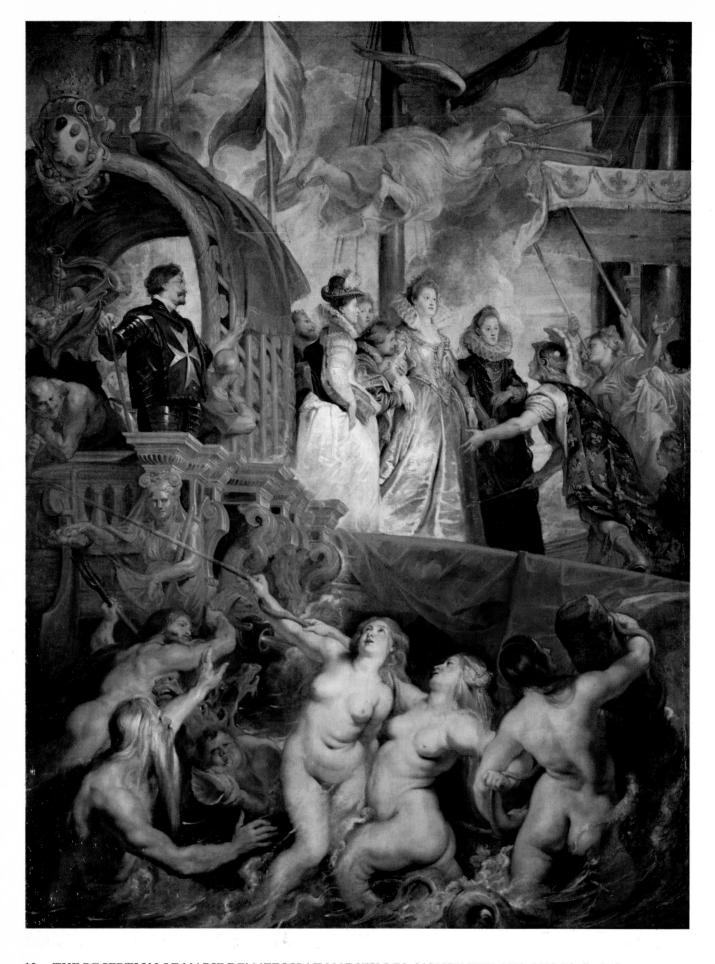

18. THE RECEPTION OF MARIE DE' MEDICI AT MARSEILLES, 3 NOVEMBER 1600. 1622-25. Paris, Louvre

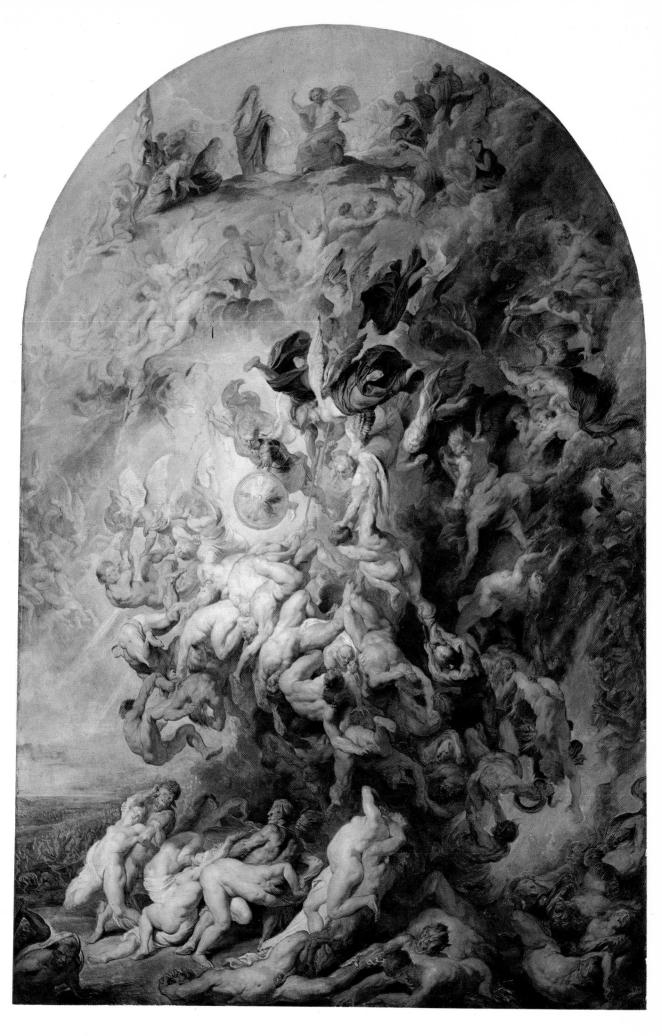

19. THE LAST JUDGEMENT. About 1620. Munich, Alte Pinakothek

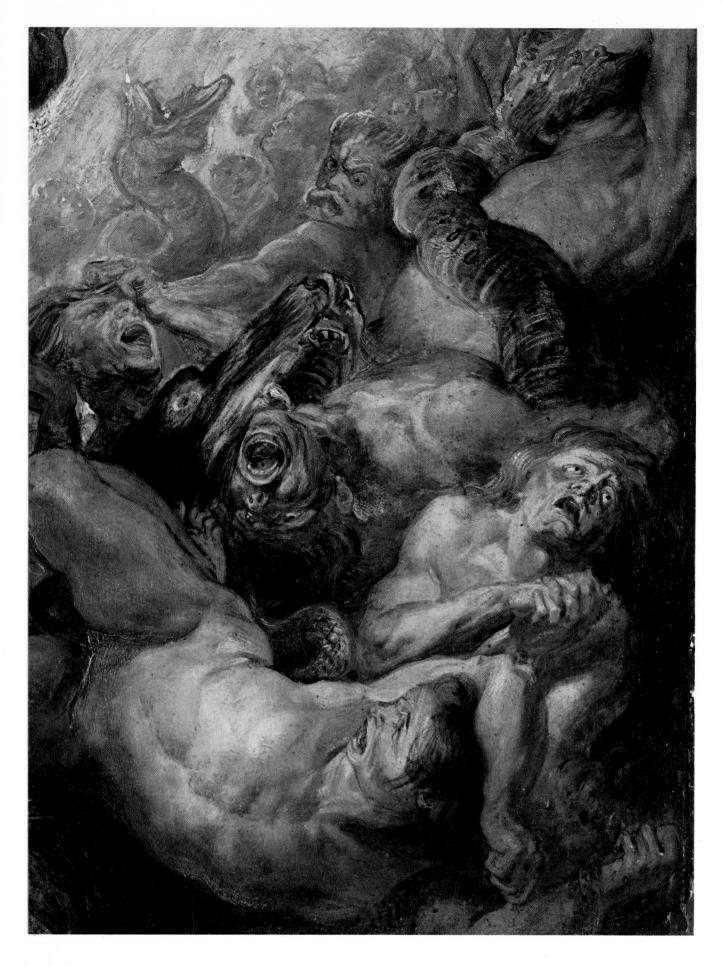

20. DETAIL OF PLATE 19

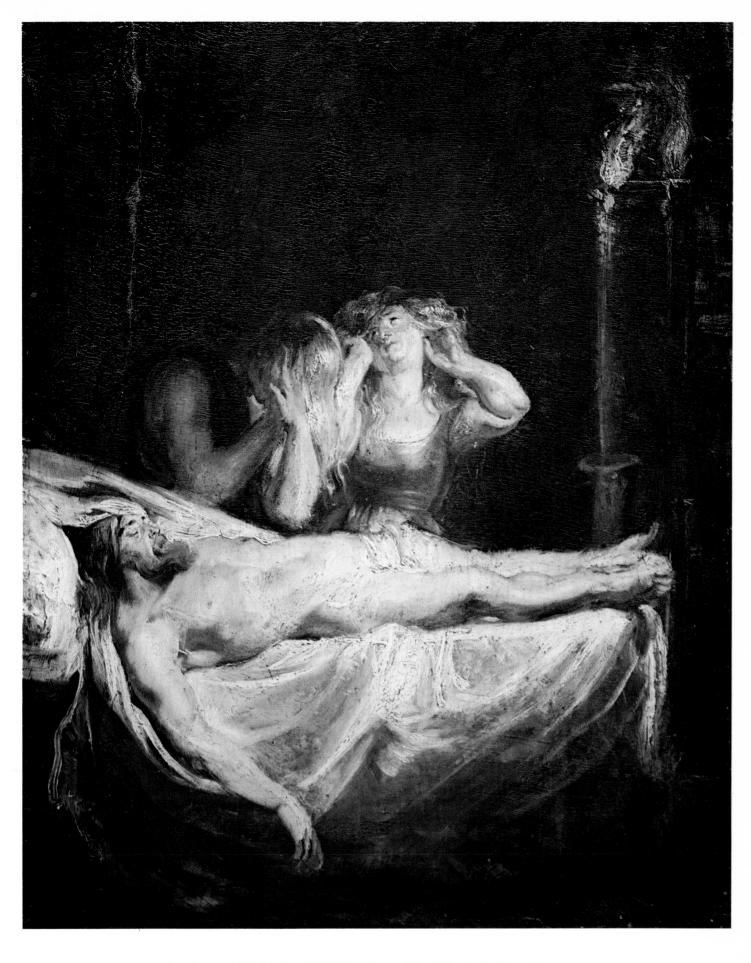

21. THE LAMENTATION OVER THE DEAD CHRIST. About 1612-14. Berlin-Dahlem, Gemäldegalerie

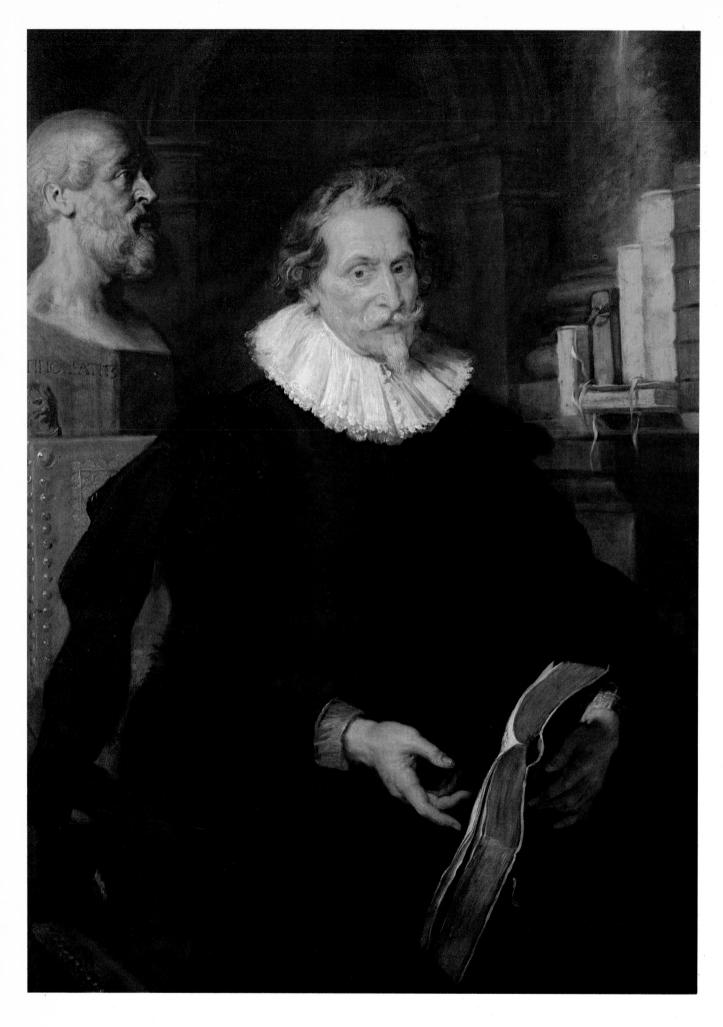

22. PORTRAIT OF LUDOVICUS NONNIUS. About 1627. England, Private Collection

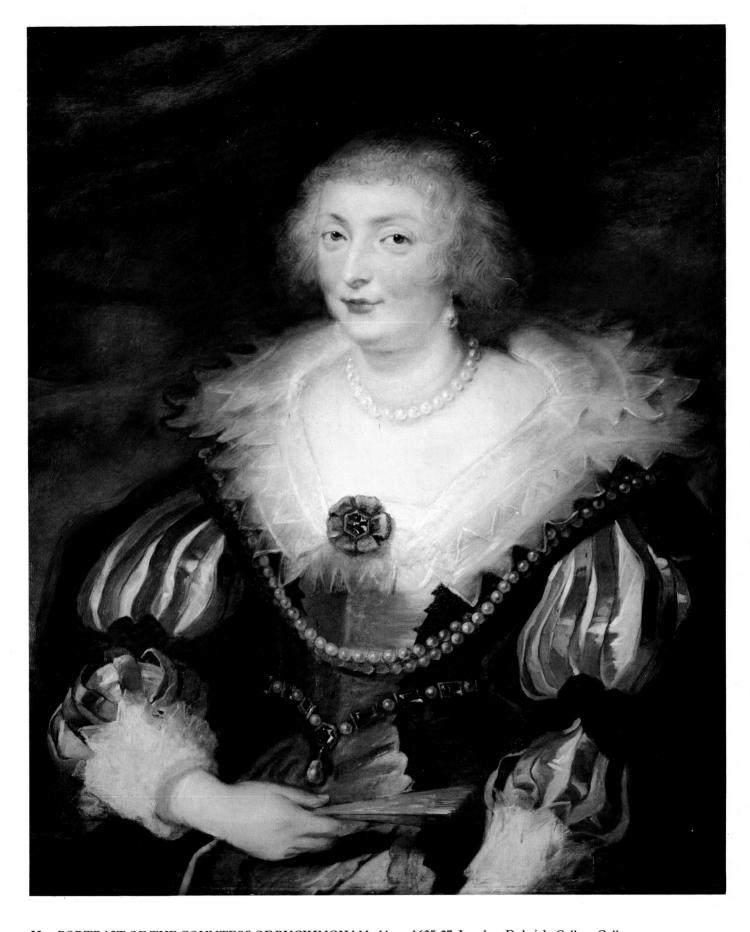

 $23. \quad \text{PORTRAIT OF THE COUNTESS OF BUCKINGHAM. About 1625-27. London, Dulwich \ College \ Gallery}$

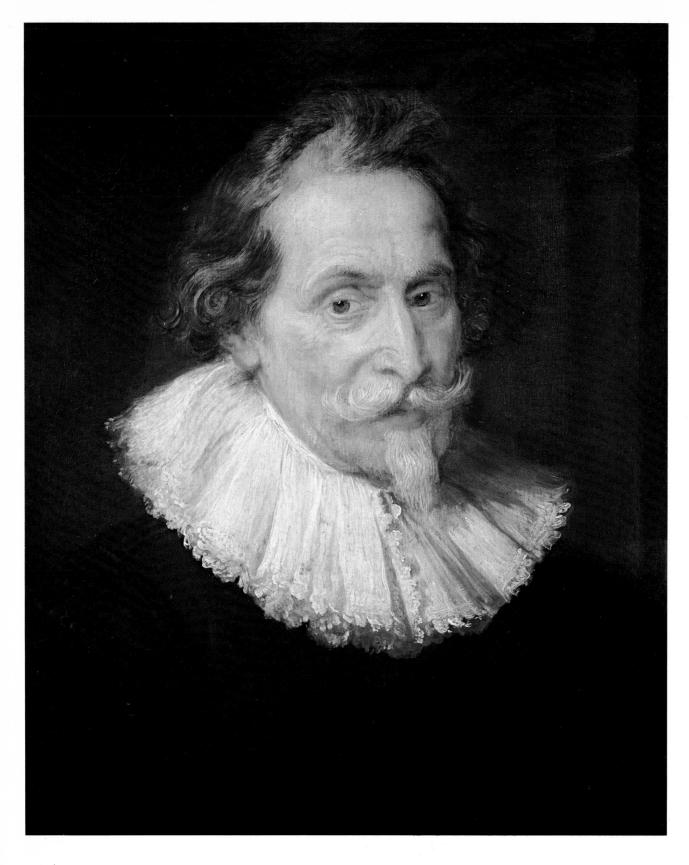

24. DETAIL OF PLATE 22

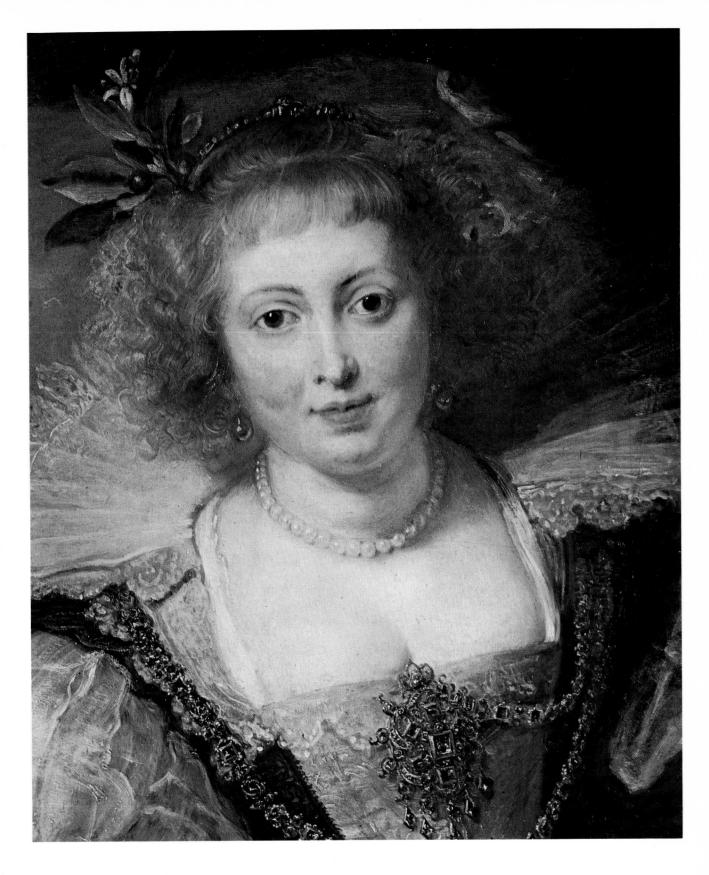

25. DETAIL OF PLATE 28

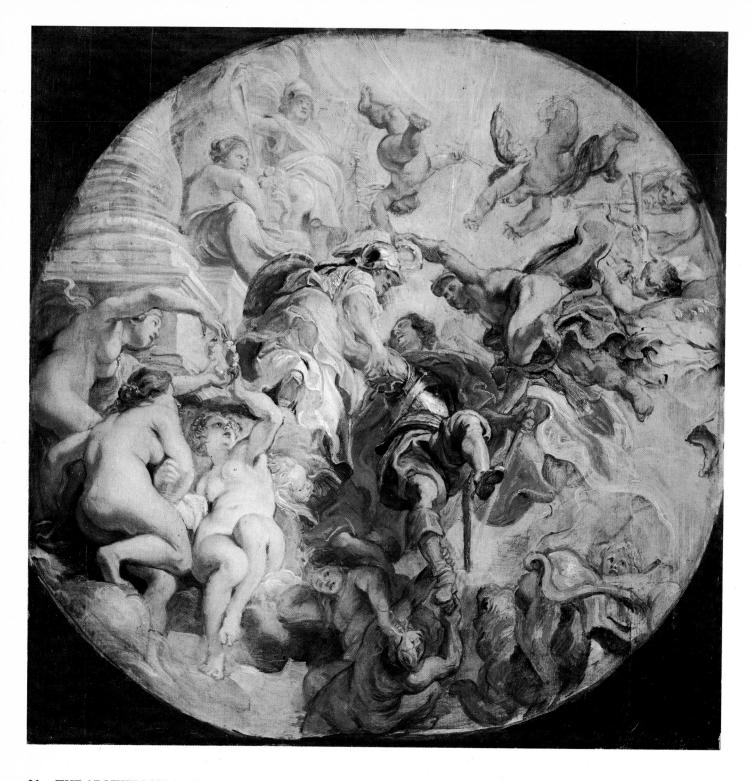

26. THE APOTHEOSIS OF THE DUKE OF BUCKINGHAM. 1625-28. London, National Gallery

27. TWO APOSTLES. About 1627. Capesthorne Hall, Cheshire, Lieut.-Col. Sir Walter Bromley Davenport

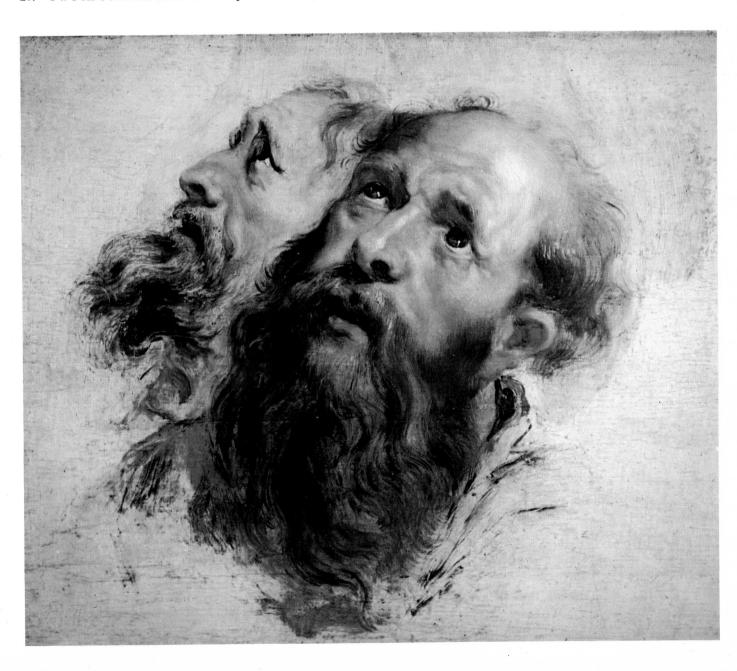

28. 'HÉLÈNE FOURMENT IN HER WEDDING DRESS.' 1630-32. Munich, Alte Pinakothek

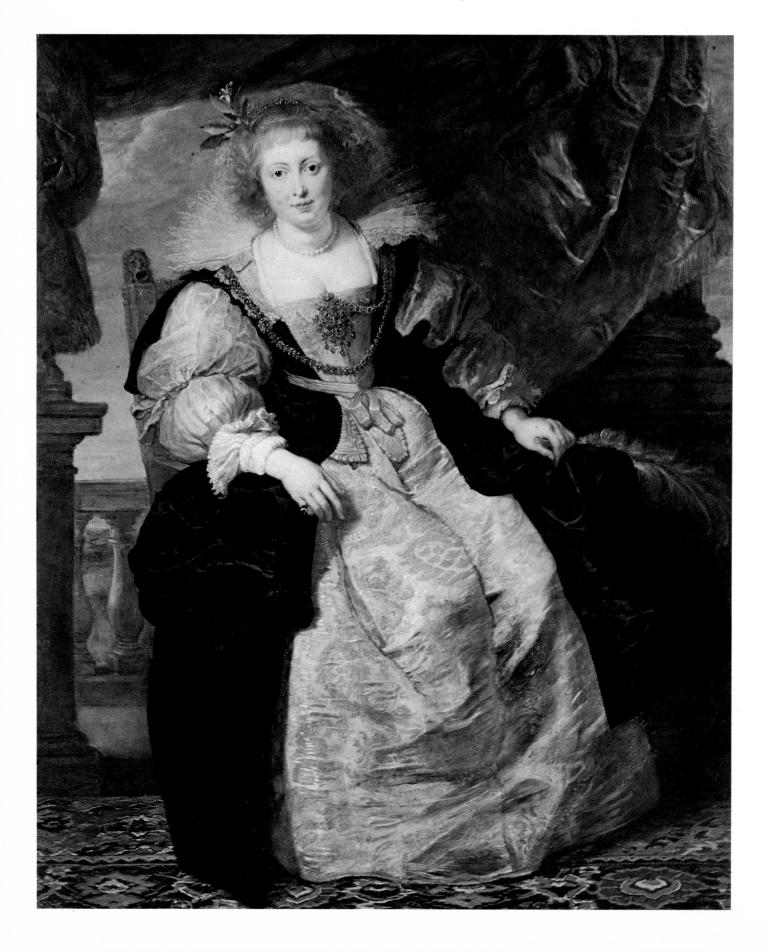

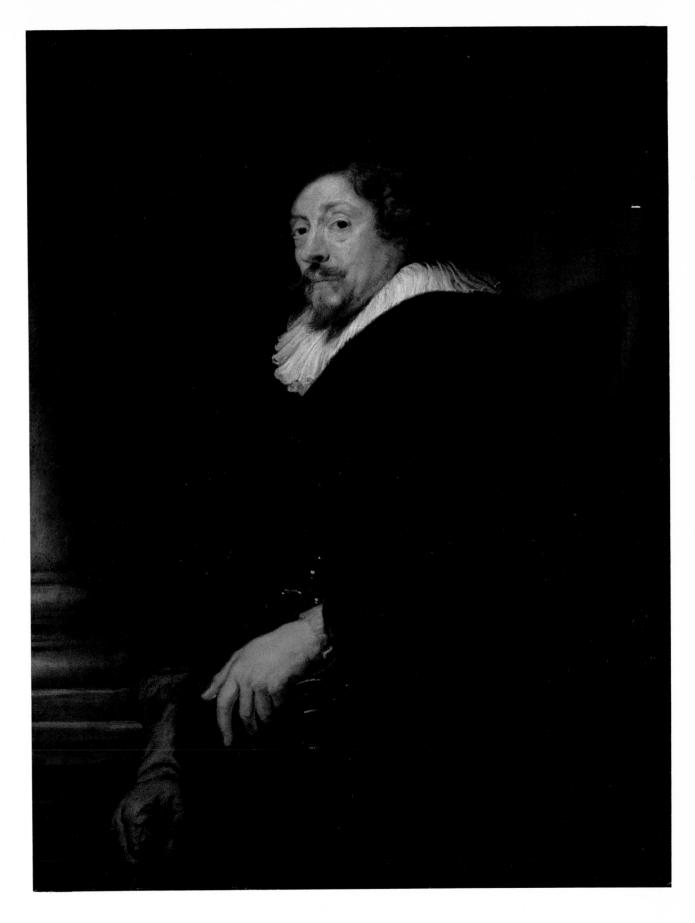

29. SELF-PORTRAIT. About 1633-35. Vienna, Kunsthistorisches Museum

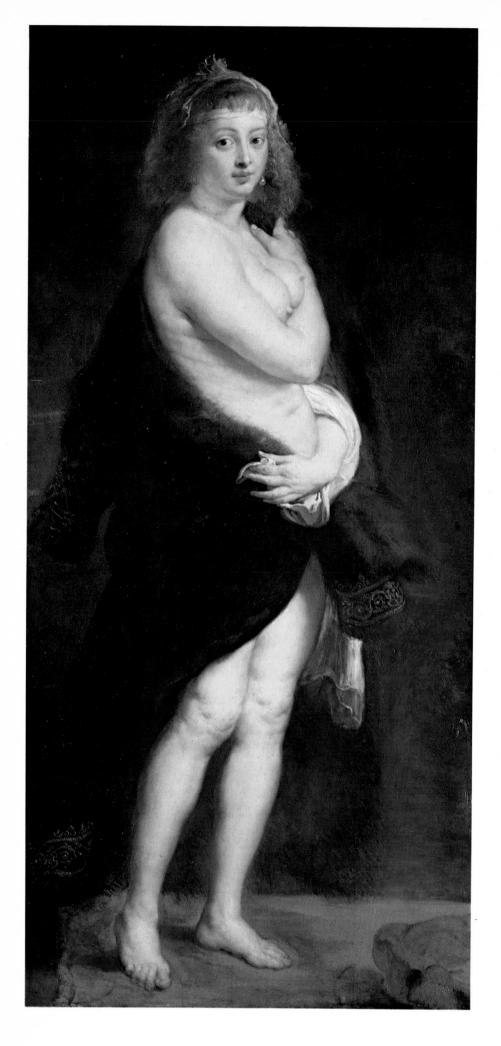

30. HELENE FOURMENT
IN A FUR WRAP.
About 1638. Vienna,
Kunsthistorisches Museum

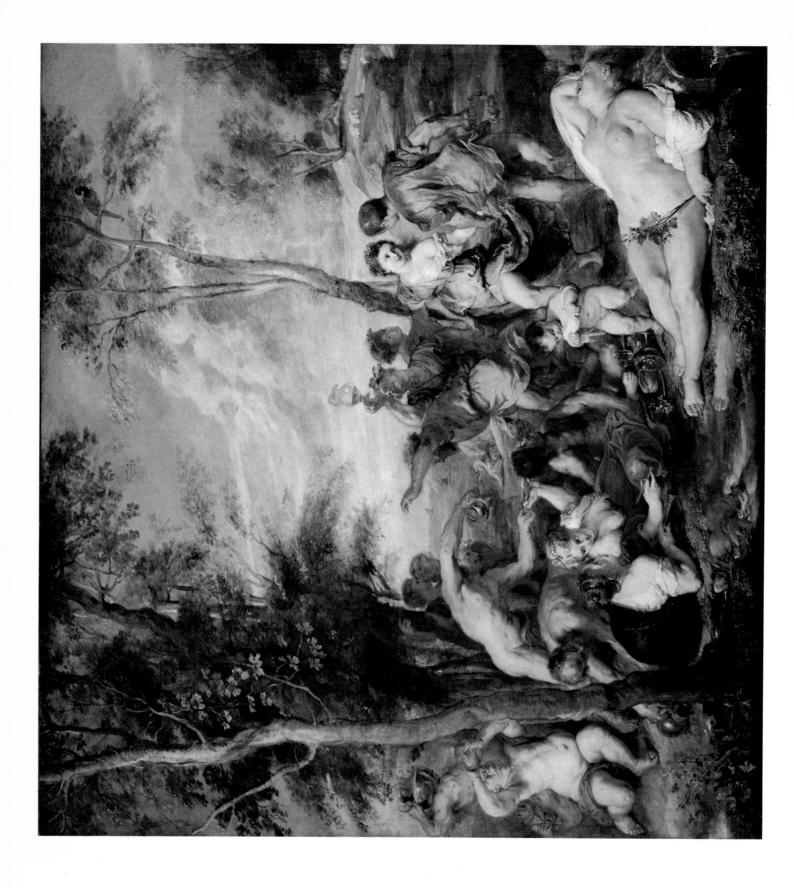

BACCHANAL (Copy after Titian). About 1636-38. Stockholm, Nationalmuseum 32.

THE RAPE OF THE SABINES. About 1635. London, National Gallery 33.

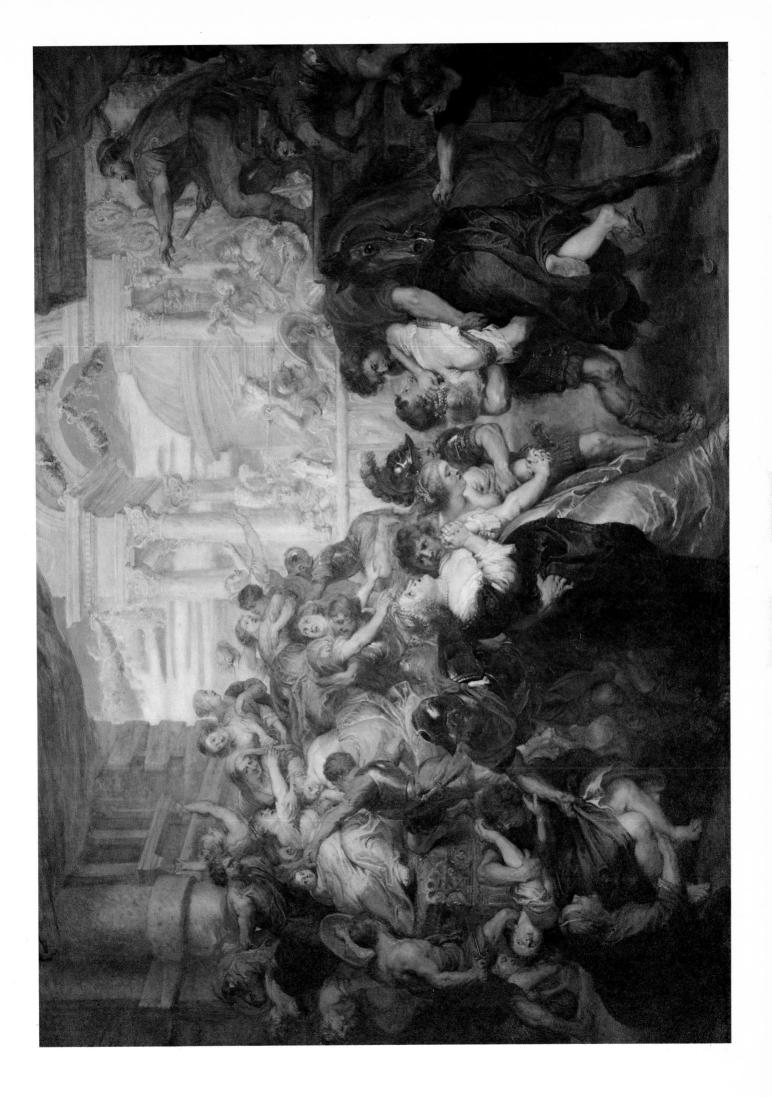

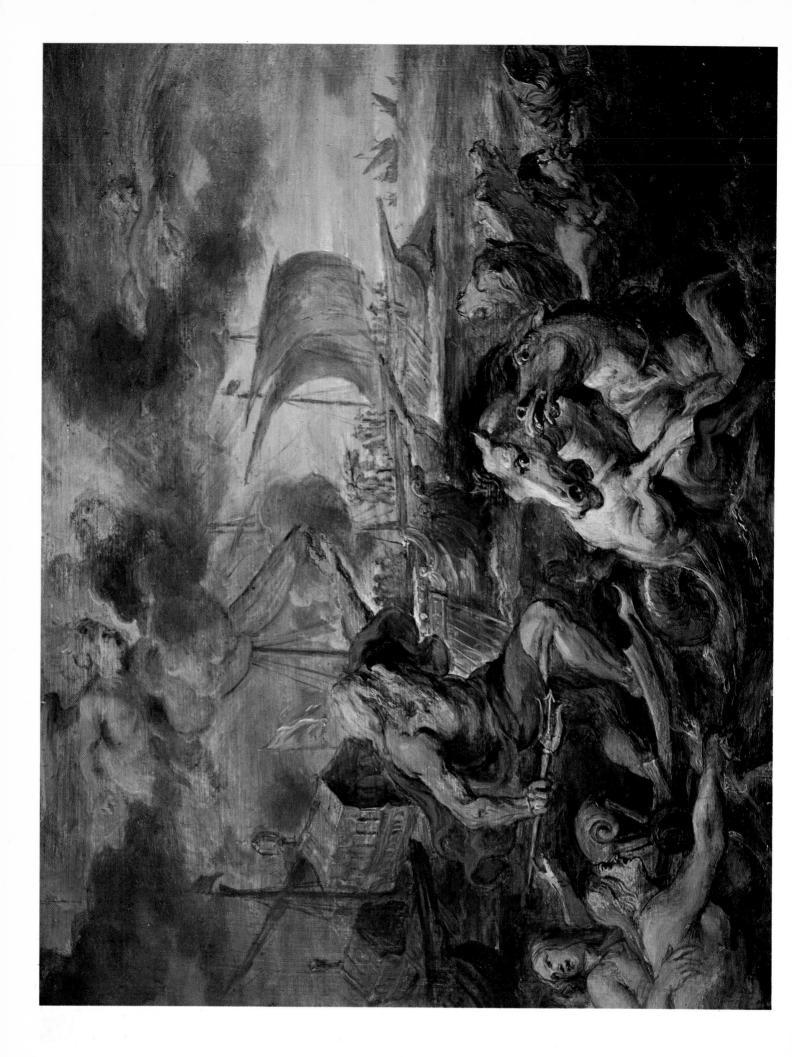

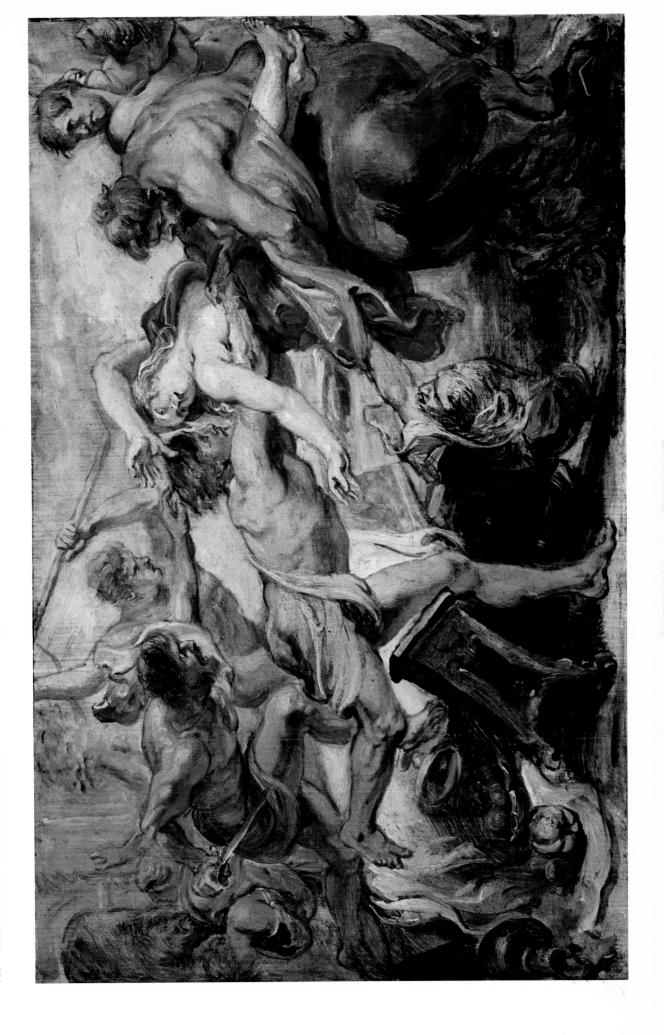

35. THE RAPE OF HIPPODAMEIA. About 1636-38. Brussels, Musée des Beaux-Arts

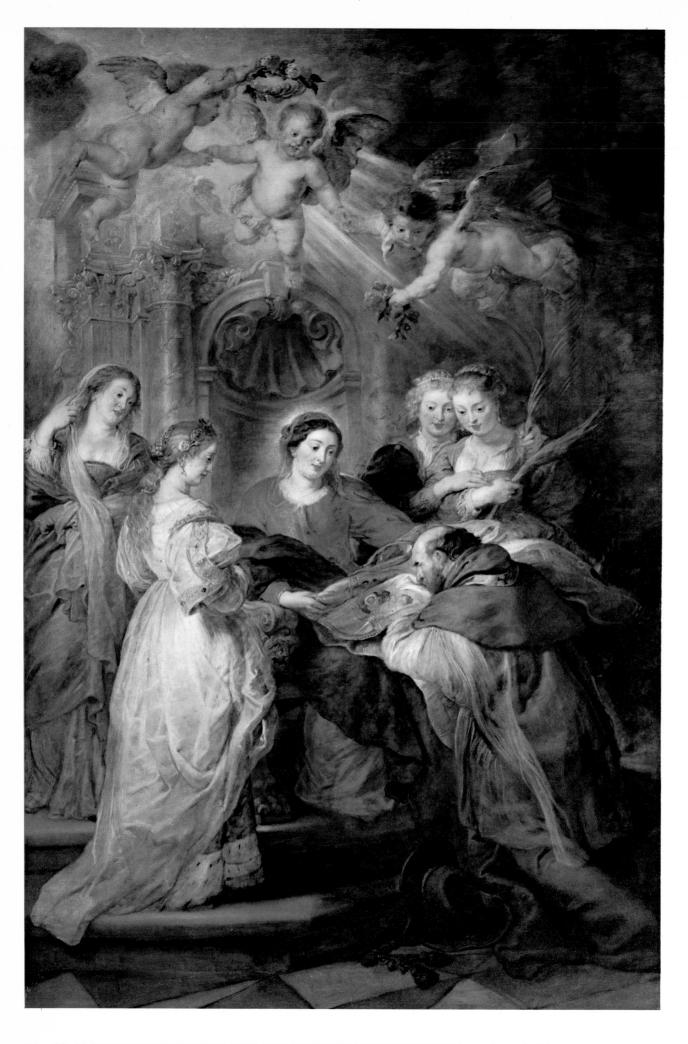

36. ST. ILDEFONSO RECEIVING THE CHASUBLE FROM THE VIRGIN (central panel of the Ildefonso Altarpiece). 1630-32. Vienna, Kunsthistorisches Museum

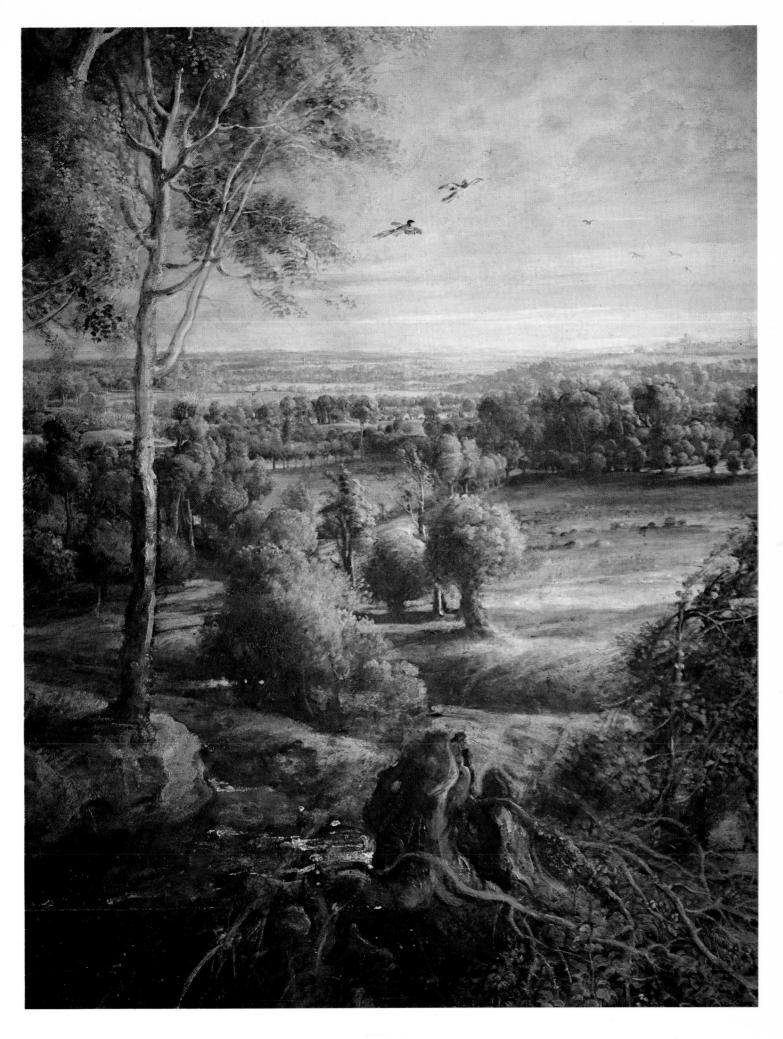

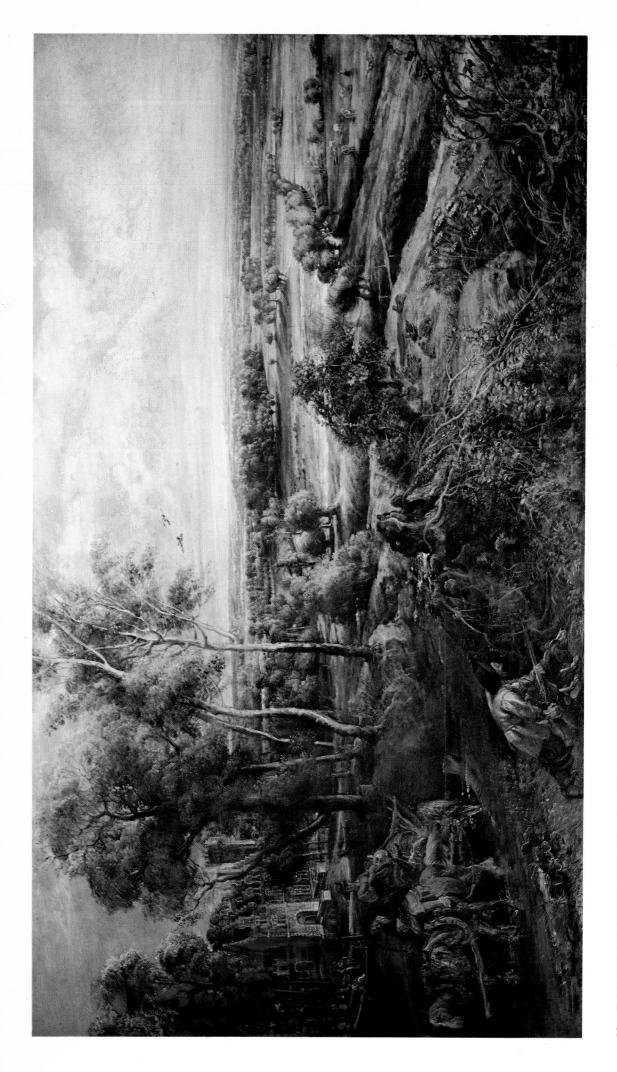

38. LANDSCAPE WITH THE CHATEAU DE STEEN. After 1635. London, National Gallery

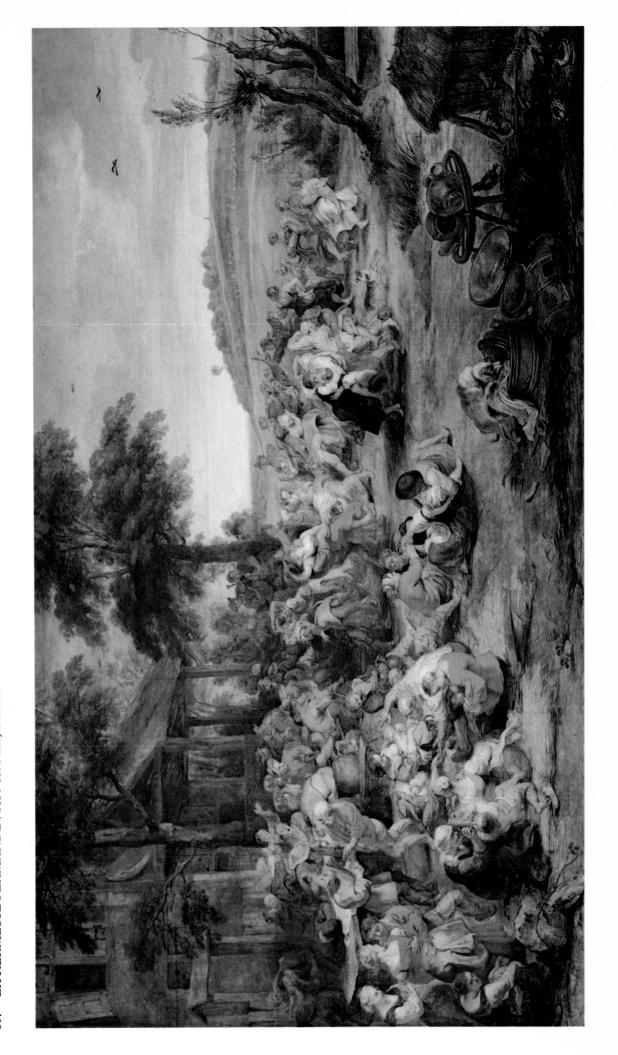

39. 'LA KERMESSE FLAMANDE'. 1630-35. Paris, Louvre

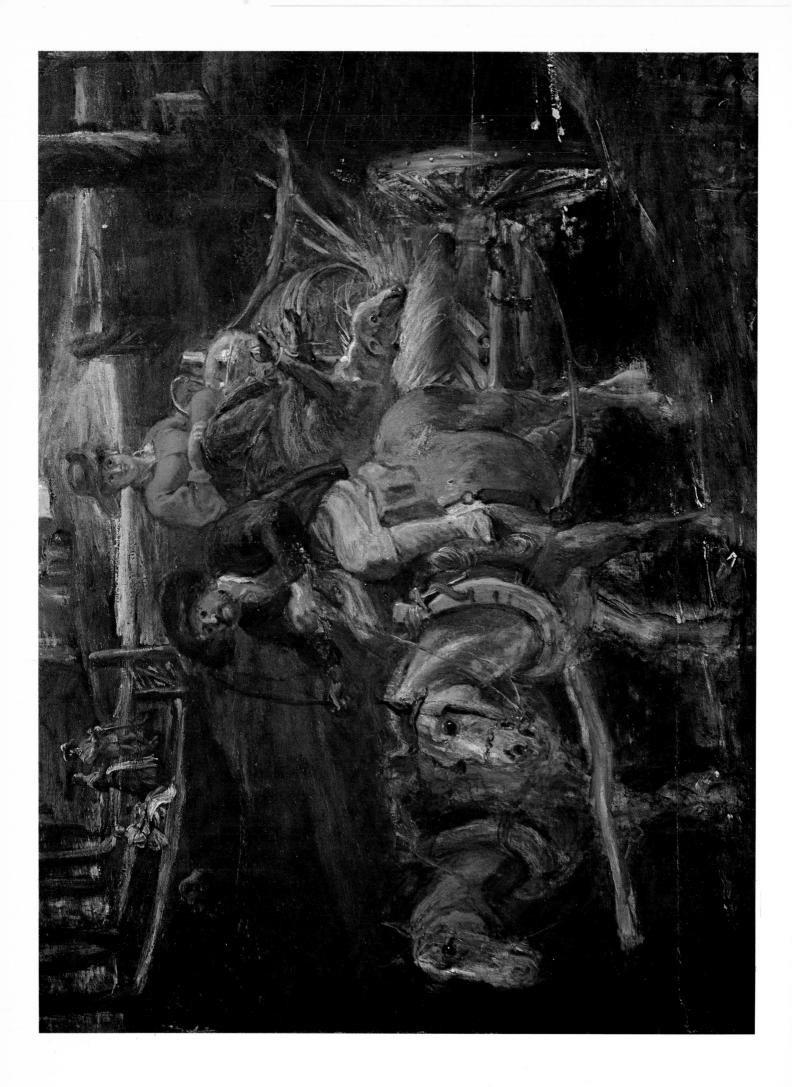

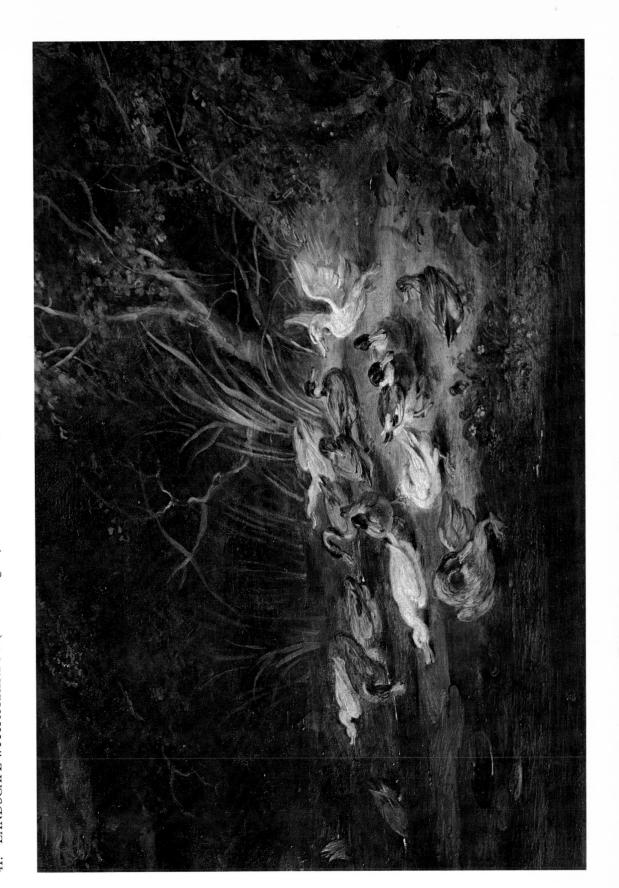

41. LANDSCAPE WITH A RAINBOW (detail of Fig. 12). After 1635. London, The Wallace Collection

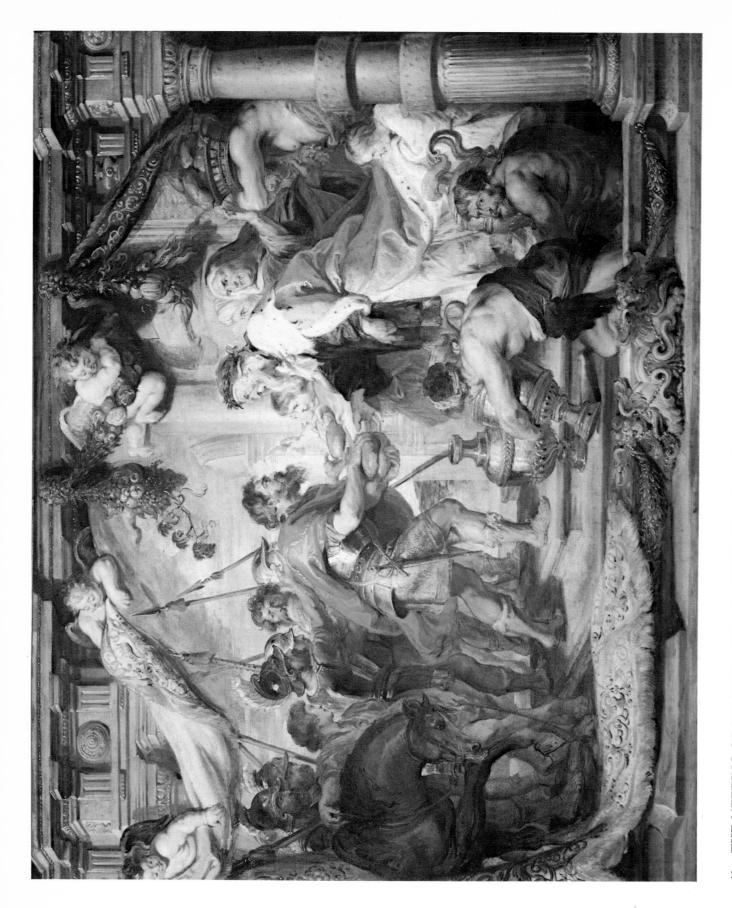

42. THE MEETING OF ABRAHAM AND MELCHIZEDEK. 1627-28. Washington, D.C., National Gallery of Art

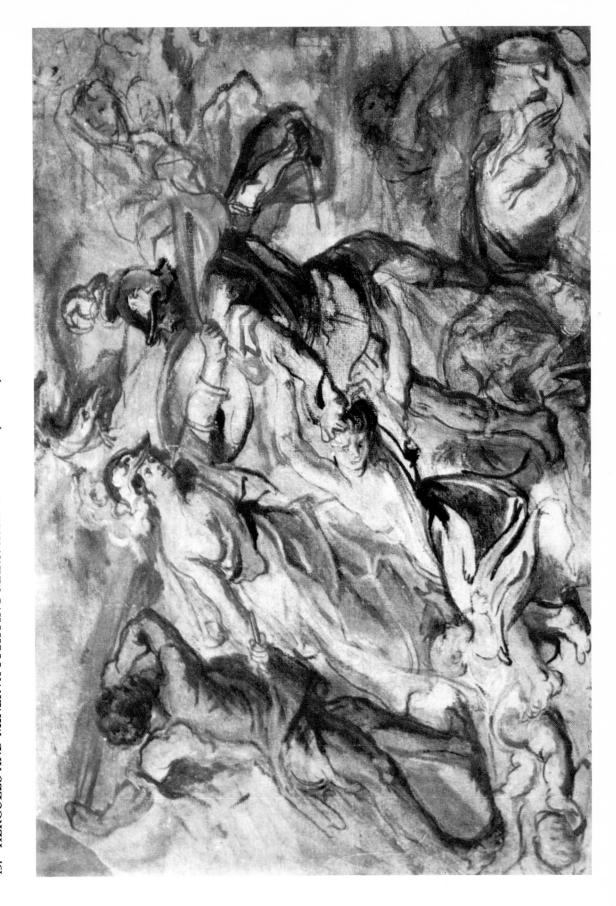

43. HERCULES AND MINERVA FIGHTING MARS. About 1635-37. Paris, Louvre, Cabinet des Dessins

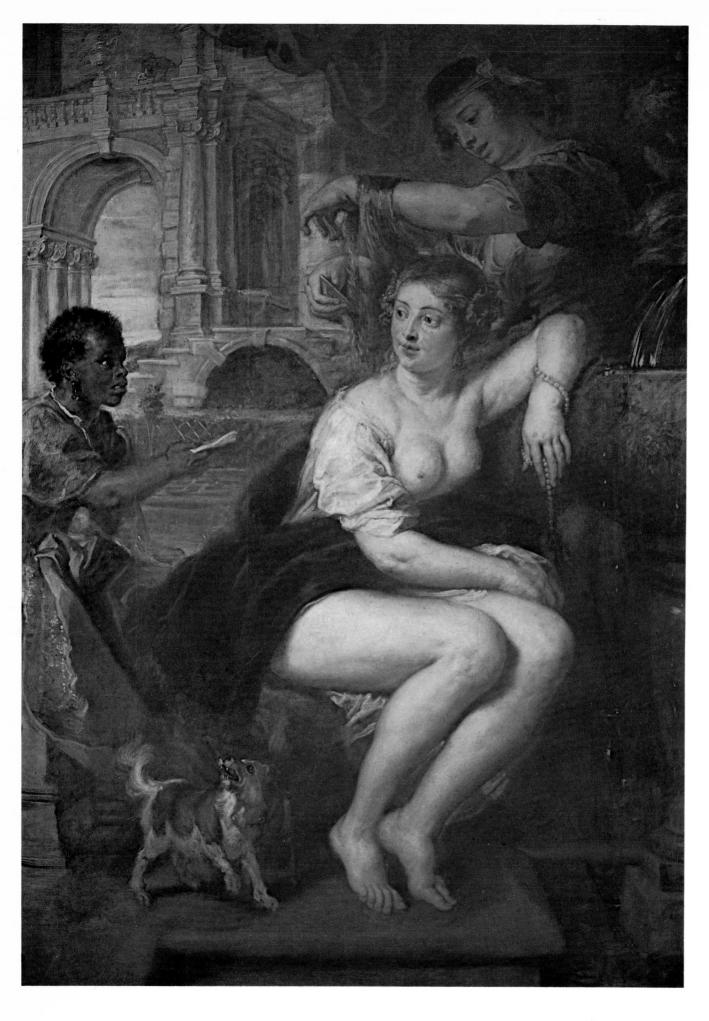

44. BATHSHEBA RECEIVING THE LETTER FROM KING DAVID. About 1636-38. Dresden, Gemaldegalerie

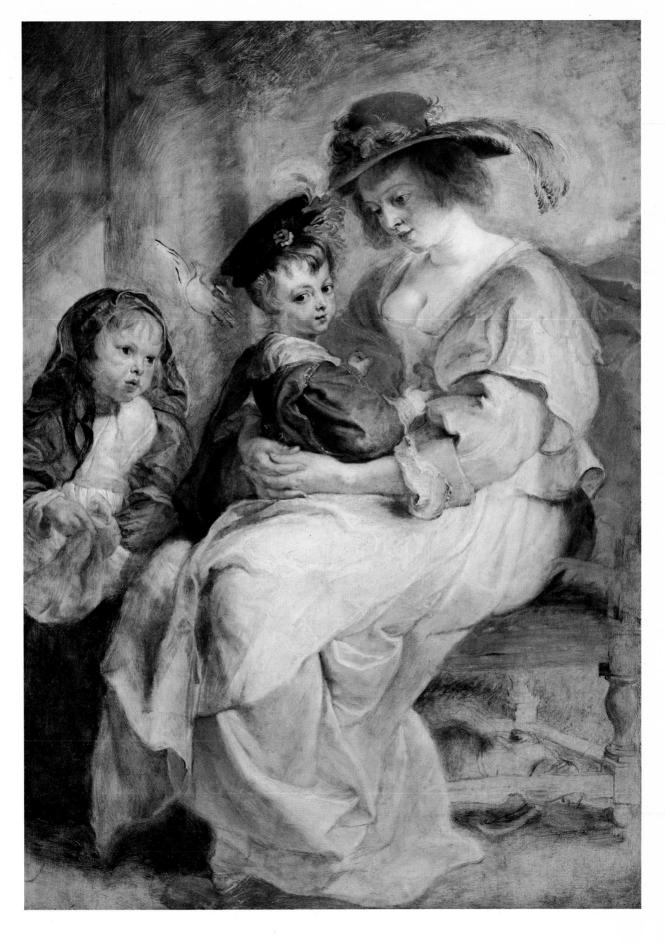

45. PORTRAIT OF HELENE FOURMENT WITH TWO OF HER CHILDREN. About 1636-37. Paris, Louvre

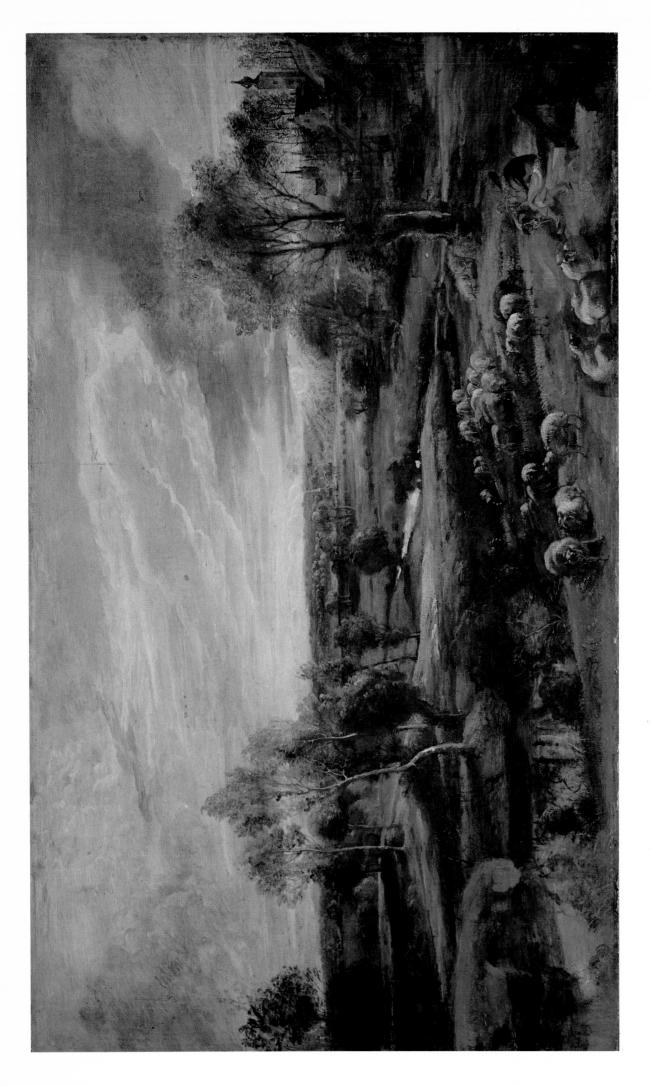

46. LANDSCAPE WITH A SUNSET. After 1635. London, National Gallery

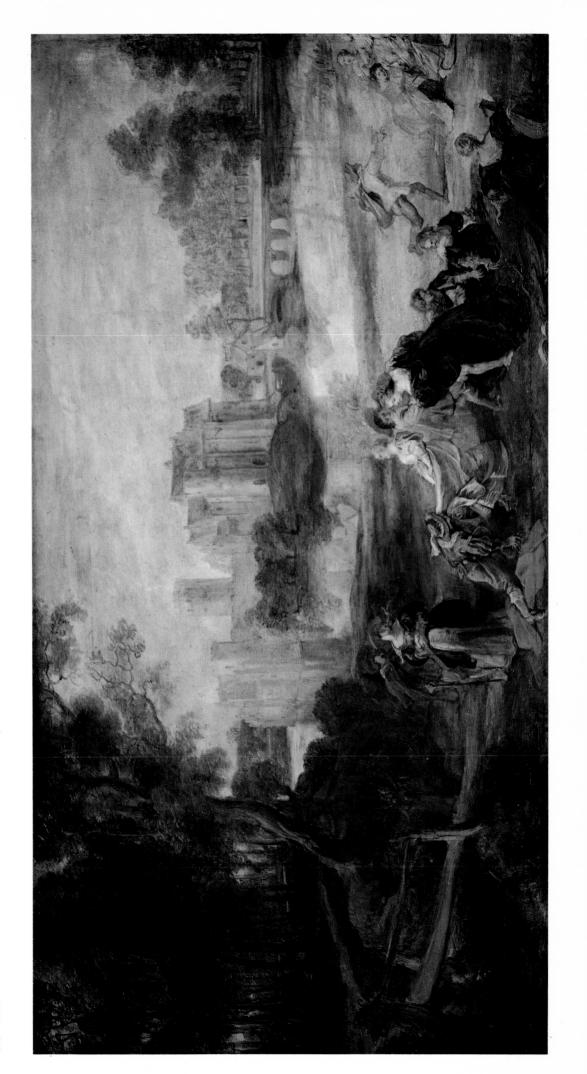

47. LANDSCAPE WITH FIGURES. After 1635. Vienna, Kunsthistorisches Museum

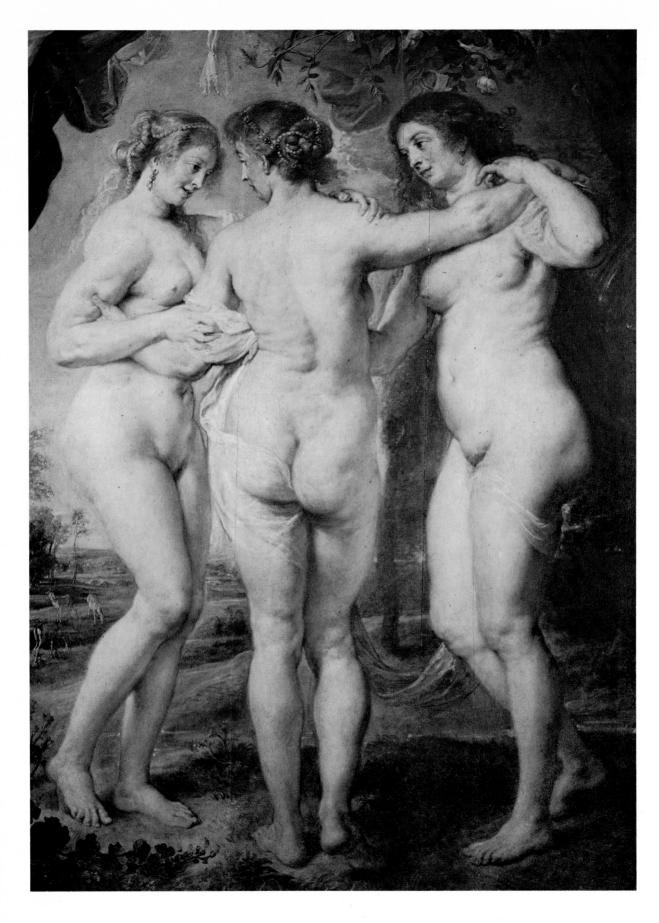

48. THE THREE GRACES (detail). About 1636-40. Madrid, Prado

List of Collections

Berlin-Dahlem, Gemäldegalerie The Lamentation over the dead Christ, 21

Brussels, Musée des Beaux-Arts The Rape of Hippodameia, 35

Cambridge (Mass.), Fogg Art Museum The Anger of Neptune ("Quos ego"), 34

Capesthorne Hall (Cheshire), Lieut.-Col. Sir Walter Bromley Davenport Two Apostles, 27

Cassel, Gemäldegalerie The Flight of the Holy Family into Egypt, 8

Dresden, Gemäldegalerie Bathsheba receiving the Letter from King David, 44 The Boar Hunt, 12

England, Private Collection Portrait of Ludovicus Nonnius, 22 & 24

The Hague, Mauritshuis Adam and Eve in Paradise (in collaboration with Jan Brueghel), Fig. 9

Kingston Lacy (Dorset), Bankes Collection The Marchesa Brigida Spinola-Doria, Fig. 3

London, British Museum Hercules, Fig. 8 Ignudo (after Michelangelo), Fig. 7 A lioness, 11 Studies for a Kermesse, Fig. 5 Trees at Sunset, Fig. 6

Buckingham Palace The Assumption of the Virgin, 7 The Farm at Laeken, 16 & 31

Courtauld Institute Gallery The Descent from the Cross, 6

Dulwich College Gallery The Flight of Saint Barbara, 9 Portrait of the Countess of Buckingham, 23

National Gallery
The Apotheosis of the Duke of Buckingham, 26
"Le châpeau de paille", Frontispiece
The Horrors of War, Fig. 11
Landscape with the Château de Steen, 37, 38 & 40
Sunset landscape, 46
The Rape of the Sabines, 33
The Triumph of Caesar (after Mantegna), Fig. 10

Count Antoine Seilern A Moonlight Landscape, Fig. 13 Copy by Rubens of Raphael's Portrait of Castiglione, Fig. 2

The Wallace Collection Landscape with a Rainbow, 41 & Fig. 12

Madrid, Prado The Apostle Simon, 3 The Three Graces, 48

Munich, Alte Pinakothek
The Battle of the Amazons, 13 & 14
Hélène Fourment in her Wedding Dress, 25 & 28
The Last Judgment, 19 & 20
The Rape of the Daughters of Leucippus, 15
Rubens and his wife, Isabella, in the Honeysuckle

Bower, 5
Paris, Louvre
Hercules and Minerva fighting Mars, 43
"La kermesse Flamande", 39
Portrait of Baldassare Castiglione (Raphael),
Fig. 1
Portrait of Hélène Fourment with two of her
Children, 45
The reception of Marie de' Medici at Marseilles,
3rd November, 1600, 18

Stockholm, Nationalmuseum Bacchanal (copy after Titian's painting of *The Andrians*), 32

Vaduz, Liechtenstein Collection Head of a Child, 10 The Toilet of Venus, 4

Vienna Albertina Portrait of a Little Boy (Nicholas Rubens?), text

Kunsthistorisches Museum The Annunciation, 2 Hélène Fourment in a Fur Wrap, 30 Landscape with Figures, 47 Landscape with Philemon and Baucis, 17 Saint Idelfonso receiving the Chasuble from the Virgin, 36 Self-portrait, 29

Washington, D.C., National Gallery of Art The Meeting of Abraham and Melchizedek, 42 Portrait of the Marchesa Brigida Spinola-Doria (Kress Collection), 1

Destroyed, Formerly Earl of Jersey Collection The Duke of Buckingham, Fig. 4

en de la composition La composition de la

Notes on the Plates

Notes on the plates

Frontispiece. "Le Châpeau de Paille" (A portrait of Susanna Fourment?). Panel, $31 \times 21\frac{1}{2}$ in. London, National Gallery.

Painted about 1625. In 1771, this portrait still belonged to the Lunden family, which was related to Rubens. The sitter is probably Susanna Fourment, Rubens second wife's elder sister. In 1623 she married Arnold Lunden, Master of the Mint. Various explanations have been given for the traditional title: "Paille" (Straw) could be a corruption of Poil (felt). The sitter wears a black beaver hat and is certainly not wearing everyday clothes. Rubens has dressed her up in what seems to be a 17th century version of Arcadian or rural costume. Spectacular hats and bare bosoms appear in Italian engravings of peasant dress and similar clothes are worn by characters in paintings illustrating Hooft's Granida, the first northern pastoral play. We know that Rubens was capable of thinking in these terms, for an inventory listing paintings once belonging to Arnold Lunden describes a portrait of Susanna Fourment "En Bergère". This portrait was popular in England before it arrived here. In 1781 Sir Joshua Reynolds saw it in the Van Haveren collection, and wrote "It has a wonderful transparency of colour, as if seen in the open air." In the early 19th century the portrait belonged to Sir Robert Peel. Turner was also interested in its "plein air" effect and he made a pencil drawing of it. The picture was cleaned and restored by the National Gallery Conservation Department in 1946. An interesting technical report with detailed photographs and X-rays was published in Museum (Unesco publication), 1950.

In text. Portrait of a Little Boy (Nicholas Rubens?). Red, black and white chalk. Pen and ink on eyes, mouth and neckline. White paper, $9\frac{15}{16} \times 7\frac{15}{16}$ in. Vienna, Albertina.

Drawn about 1619. The sitter is probably Rubens' second son, Nicholas, who was born in March, 1618. Rubens often used his children as models. He used this study for the head of the Christ child in *The Virgin with the penitent sinners* (Cassel).

1. Portrait of the Marchesa Brigida Spinola-Doria. Canvas (cut down), $60 \times 38\frac{3}{4}$ in. Washington, D.C., National Gallery of Art (Kress Collection).

Painted in 1606. At some date after 1851, this painting was cut down, losing a third of its length and narrow strips on either side. An inscription, giving the date of the portrait, as well as the name and age of sitter, originally on the lower left corner, was subsequently copied on to the back of the canvas. Brigida Spinola, a Genoese noblewoman, was 22 when Rubens painted her in the year of her marriage to Giacomo Massimiliano Doria. The magnificent white satin dress was probably her bridal gown. In a pen and ink drawing (Edmund Schilling collection, London) Rubens worked out his full length composition and aided his memory by writing brief colour notes in Flemish.

2. The Annunciation. Canvas, $88 \times 78\frac{3}{4}$ in. Vienna, Kunsthistorisches Museum.

Painted, about 1609-10, for the Maison Professe, the headquarters of the Antwerp Jesuits, where it remained until the 18th century. It documents the beginning of Rubens' lifelong association with the Flemish Jesuits. Like many of his generation, Rubens was baptised a Protestant but grew up to be a devout Catholic who attended Mass every morning before painting. He lived near the centres of religious controversy. He frequently illustrated Jesuit theological and scientific books and was well read in both Protestant and Catholic propaganda literature. Rubens certainly knew Ignatius Loyola's Spiritual Exercises. Here he is painting for a community trained to visualise Biblical episodes in great detail, and accustomed to meditating on them in solitude and darkness. Rubens, fresh from Caravaggio's Rome, visualises the Annunciation at night. He brings us extremely close to the figures; we are granted a temporary revelation. The transitory nature of the event is emphasised by the way the frame cuts the angel's garments. The miracle of the Incarnation is expressed by colour contrasts, by Mary's virginal white and cold blue against the hot flame drapery of the angel. This work shows Rubens under Barocci's influence; he had an opportunity of studying his work at first hand when painting the altarpiece for Santa Maria in Vallicella in Rome. Barocci was Saint Philip Neri's favourite painter and his pictures decorated that church.

3. The Apostle Simon. Panel, $42\frac{1}{2}\times33$ in. Madrid, Prado. Painted about 1613. In a letter of 1618, Rubens offered Sir Dudley Carleton paintings of Christ and the Twelve Apostles. He described these pictures as studio copies of an original series that he had made for the Duke of Lerma, Prime Minister to Philip III of Spain. The Christ has been lost but the life-size apostles are all in the Prado. The studio copies for which Rubens was only going to charge 50 florins per head can probably be identified with the pictures in the Galleria Pallavicini in Rome. The Apostle Simon cannot have been painted during Rubens' visit to Spain in 1603, and unpublished documents discovered by Michael Jaffé, together with stylistic evidence, suggest a date around 1613.

4. The Toilet of Venus. Panel, $48\frac{7}{8} \times 38\frac{1}{2}$ in. Vaduz, Liechtenstein Collection.

Painted about 1613. A collector's piece, set within a 16th century Venetian iconographic tradition. This is a domesticated "Venus Vanitas"; and a painting in which Rubens has tried to suggest an almost sculptural solidity of form. As usual, he was well aware of how his great predecessors had treated the subject: he made a copy, now in the Thyssen Collection, of Titian's Venus and Cupid with a Mirror, either from the version now in Washington, or a variant. The figure of Venus recurs, similarly posed but in a different context, in The Crowning of a Hero (Munich, Alte Pinakothek).

5. Rubens and His Wife, Isabella, in the Honeysuckle Bower. Canvas, $68\frac{1}{2}\times52$ in. Alte Pinakothek, Munich. 1609-10.

Painted 1609-10, this portrait commemorates Rubens' marriage to the 17-year-old Isabella Brant on October 3rd, 1609. Isabella's father, Jan Brant, was an eminent Antwerp lawyer and humanist. Earlier in the same year, Rubens' brother Phillip had married Maria de Moy, Isabella's aunt. It was through members of the Brant family living in Holland that Rubens seems to have been drawn into a diplomatic career. Isabella bore Rubens three children. She died in 1626 and Rubens' marriage, which had opened with such a beautiful picture, was concluded by a moving letter: "Truly I have lost an excellent companion whom one could love - indeed had to love, with good reason - as having none of the faults of her sex. She had no capricious moods, no feminine weakness, but was all goodness and honesty, and because of her virtues she was loved during her lifetime and mourned by all at her death. Such a loss seems to me worthy of deep feeling." (Rubens to Pierre Dupuv, July 1626.)

6. The Descent from the Cross. Panel, 45×30 in. London, Courtauld Institute Gallery.

Probably a preliminary study, done about 1611, for the central panel of The Descent from the Cross painted in Antwerp between 1011-14. This modello is of high quality. X-rays have revealed pentimenti in the area of the shroud and the left arm of the Virgin. It could have been submitted to Rubens' patrons for approval before he went ahead on the large scale work. The Descent from the Cross was painted for the Guild of Arquebusiers, a kind of military club, or shooting company, which had been founded in 1490. Rubens' friend and future patron, Nicholas Rockox, was an official of this club and it may have been he who procured the commission for Rubens, who included his portrait in the panel of The Presentation. In 1615, Rubens actually joined the Guild and was exempted from his subscription. The altarpiece was destined for the south aisle of the gothic Cathedral and was commissioned in September, 1611; the central panel was delivered in the following September. The wings were completed in February and March, 1614. The Guild's patron was St. Christopher. An old tradition relates that Rubens was reluctant to paint that saint in the central panel and that he persuaded the Guild to accept a much more ambitious scheme, one that would be an appropriate counterpart to his great altarpiece of The Raising of the Cross, painted for St. Walburga in 1610-11. Rubens played on the Greek meaning of Christopher - Christ-bearer. In his central panel Christ is born by the Cross; in the left wing, depicting the Visitation, he is carried in the Virgin's womb; while in the right, Simeon holds him in his arms. On the outside of the wings St. Christopher is shown carrying Christ across the stream. The Descent is an inspired amalgamation of compositional motives learnt in Italy, from studying the work of Daniele da Volterra, Barocci and Cigoli.

It was Rubens' large altarpieces which established his reputation and supremacy in Northern Europe. Knowledge of them was circulated by innumerable versions and copies. In 1620, Lucas Vosterman made an engraving of *The Descent from the Cross*. Appreciation of what might appear to us to be a very Catholic style was not limited to Catholic countries. Rubens' work was popular in Holland and was especially

appreciated at the Stadtholder's Court in The Hague. Rembrandt was certainly aware of Rubens' great altarpieces, and in the 1630's was trying to imitate their violent overall movement.

7. The Assumption of the Virgin. Panel, $40\frac{1}{4} \times 26$ in. London, Buckingham Palace. (Reproduced by gracious permission of Her Majesty the Queen.)

This is a highly finished modello, done in the period 1611-15. It is fully authenticated by a very detailed engraving produced by Schelte à Bolswert about 1650. None of Rubens existing altarpieces of the Assumption corresponds to this sketch but Rubens made use of ideas contained in it. The upper part reappears in the Vienna Assumption (about 1613-14), the lower part with some alterations in the Brussels Assumption (about 1615-16). A drawing in the Albertina, Vienna, is closely related to the modello.

The Flight of the Holy Family into Egypt. Panel, $15\frac{3}{4} \times 20\frac{7}{8}$ in. Cassel, Gemäldegalerie Gallery.

In its scale, theme and use of moonlight, this painting of 1614 illustrates Rubens' interest in the work of the German land-scape painter, Adam Elsheimer, whom he had met when in Rome. In 1611, the year after Elsheimer's death, Rubens wrote to Johann Faber, a German doctor in Rome, telling him: "I should like to have that picture on copper (of which you write) of the Flight of Our Lady into Egypt come into the hands of one of my compatriots who might bring it to this country." In this postscript he told his friend to assure Elsheimer's widow that he would do all he could to find a buyer for *The Flight*, and that he was willing to advance her a part of its price.

Rubens is here concerned with a contrast between the natural moonlight reflected in the water and the supernatural holy light emanating from Mary and the Child. At this stage, Rubens was not interested in pure landscape painting; his version of *The Flight* is less poetic than Elsheimer's, but more dramatic. A feeling of urgency is reinforced by Joseph, who turns back as if afraid that he and his family are being followed.

9. The Flight of St. Barbara. Panel, $12\frac{7}{8} \times 18\frac{1}{4}$ in. London, Dulwich College Gallery.

A modello for one of the ceiling panels in the south aisle of St. Charles Borromeo, the Jesuit church in Antwerp, newly built and dedicated by the Bishop of Antwerp in September, 1621. In 1620, Rubens had painted two altarpieces for this church, depicting the miracles of St. Ignatius Loyala and St. Francis Xavier (now in the Kunsthistorisches Museum, Vienna), and in 1620, he promised to provide 39 paintings for the ceiling of the aisles and galleries. These pictures had to be finished by the end of the year, and it was agreed that Van Dyck and other pupils could be used to execute the works, though all the sketches had to be by Rubens himself. Rubens' paintings were destroyed by a fire in 1728 but we can get some idea of the arrangement from a drawing made by Jacob de Wit and engravings by J. Punt. The paintings for the galleries were alternating square and octagonal, while those for the aisles were oval and octagonal. Each picture was divided from the next by a heavy wooden frame. Old Testament scenes served as pre-figurations of the New

Testament paintings and episodes from the lives of the saints. Rubens introduced into Northern Europe those "di sotto in su" effects learnt from his study of Venetian ceiling paintings, from Veronese in S. Sebastiano and Titian in Santo Spirito in Isola. This was the first opportunity that Rubens had of designing a full scale decoration for a modern interior, but he must have been aware that many of those illusionistic effects that he had seen in Italy could not be introduced into Northern Europe until major changes had taken place in architectural design. He had made a study of Correggio's domes in Parma but Antwerp had no domes and in 1620 was still a "gothic" city.

The St. Barbara modello was originally an oblong octagon but the corners have been filled in by later additions. In each of his panels, Rubens presents the climax of an action. In this case he has amalgamated events from the saint's life and, contrary to the "Golden Legend" narrative, he puts her flight from her father a split second before her martyrdom. The tower is Barbara's emblem: her father, enraged by her constant refusal to marry, imprisoned her in a tower while he went away on a journey. There is a preliminary grisaille sketch for the St. Barbara in the Ashmoleum Museum, Oxford.

10. Head of a Child. Panel, $14\frac{1}{2} \times 10\frac{5}{8}$ in. Vaduz, Liechtenstein Collection.

Painted about 1618. The sitter has not been identified, but it has been suggested that she might be Rubens' eldest daughter, Clara Serena, who died aged 12 in 1623. A painted sketch of this kind must have been made by Rubens for himself or for a member of his family. A portrait, on panel of Clara Serena was recorded in the estate of her grandfather, Jan Brant.

11. A Lioness. Black and yellow chalk, washed white body colour, $12 \times 9\frac{1}{4}$ in. London, British Museum.

This study of about 1614-15 was made in connection with a painting of *Daniel in the Lion's Den* which was once in the Hamilton collection, and has recently been acquired by the National Gallery of Art, Washington, D.C. In 1618 Rubens offered Sir Dudley Carleton, English Ambassador to The Hague, a "Daniel between many lions done from life, an original entirely by my own hand 600 florins". Although Rubens made his drawing of the lion from the life, he derived its pose from a Paduan bronze statuette. This study once belonged to the painter, Thomas Lawrence.

12. The Boar Hunt. Panel, $54 \times 66\frac{1}{2}$ in. Dresden, Gemäldegalerie.

This picture, painted about 1616-18, decorated the large hall in Rubens' Antwerp house. In 1627, he sold it to the Duke of Buckingham, who also owned a *Lion Hunt* by Rubens. A picture of this type was bound to be popular with aristocratic patrons who spent much of their spare time riding and hunting.

The landscape was assembled from separately studied details: the fallen tree trunk, for example - which plays a vital part in defining the spatial recession - was based on a study now in the Louvre. Rubens used this drawing on more than one occasion. The gnarled character of the fallen tree trunk is typical of this phase of his career, when he was still

very attracted by exceptional, often dramatic, elements in nature.

13. The Battle of the Amazons. Canvas, $47\frac{1}{2}\times65$ in. Munich, Alte Pinakothek.

Executed about 1618, this picture belonged to Rubens' friend Cornelius van der Geest, an Antwerp merchant and connoisseur who had helped him gain the commission for *The Raising of the Cross* in 1610. The painting is reproduced in *The Studio of Apelles*, a painting of van der Geest's collection by Wilhelm van Haecht. According to Roger de Piles, the subject is taken from Herodotus.

The Amazons, led by their queen Thalestris, are pursued by the Greeks commanded by Theseus; they are making a last effort to defend their standard on a bridge over the river Thermodon. Roger de Piles, who analysed this picture when it hung in the Duc de Richelieu's collection in the 1680's, was amazed by the numbers of the figures and the complexity of the grouping. Rubens seems to have been particularly proud of it for as early as 1619 he was taking great pains to see that knowledge of it would be circulated by good engravings. Rubens often used his engravings to gain favour with great patrons; and prints of The Battle of the Amazons were dedicated to Althea Talbot, the Duke of Arundel's wife. This battle-piece is a 17th century response to Titian's Battle of Cadore and Leonardo's Battle of Anghiari. Delacroix was particularly impressed by its savagery, energy and movement. He made a special copy of that part of the picture reproduced in plate 14.

14. Detail of Plate 13.

15. The Rape of the Daughters of Leucippus. Canvas, $87\frac{3}{8} \times 82\frac{1}{4}$ in. Munich, Alte Pinakothek.

The twins Castor and Pollux, famous for their equestrian skill, abducted the two sisters Phoebe and Hilaria, daughters of the priest Leucippus. They were pursued by Idus and Lynceus, who were engaged to the girls. Castor was killed in the fight that followed and Zeus allowed Pollux to die as well. They were given a place amongst the stars and became the Gemini.

Painted about 1618, the composition is borrowed from a group of fighting horsemen that Rubens had copied from Leonardo's Battle of Anghiari. The airborne daughter is taken from a figure in Luca del Cambiaso's Rape of the Sabines, a fresco in the Palazzo Imperiale at Genoa. Cambiaso's figure traces its pedigree back to Michelangelo's Leda, which Rubens had also copied. Rubens' prototype was singularly appropriate: Castor and Pollux were Leda's sons by Zeus. Rubens' approach to mythology is here very close to the young Bernini's and the painting should be compared with Bernini's slightly later Rape of Proserpina, a group now in the Borghese Gallery in Rome. Both artists are concerned with the expression of sexual desire and with movement reinforced by wind-blown drapery. Rubens heightens the contrast between male and female flesh tones. The sisters are different, but their common fate is emphasised by the deliberate "rhyming" of their limbs. Rubens encloses the double drama within a compositional scheme that resembles a diamond pivoting on its point. It is interesting to see that, although well versed in classical

literature, he has deliberately chosen to ignore the texts. Castor and Pollux should be riding white horses but this colour would have reduced the contrast between male and female flesh. Sir Joshua Reynolds saw a painting of this subject hanging in Rubens' house in Antwerp.

16. The Farm at Laeken. Panel, $33\frac{1}{4} \times 49\frac{1}{2}$ in. London, Buckingham Palace (reproduced by gracious permission of Her Majesty the Queen).

Painted about 1618. Rubens often enlarged his landscapes as he worked on them. In this case he added $2\frac{3}{4}$ in. to the left and 5 in. at the top and bottom. The church in the background is a simplified version of the building that existed at Laeken until it was demolished in 1894. Until 1819 this picture remained in the possession of the Lunden family, descendants of Rubens' daughter, Isabella. An 18th century writer records that Louis XV tried to buy it in 1746 for 12,000 florins. The Farm at Laeken is closely related to two other pastoral landscapes, one in Munich, the other in Berlin. A 17th century spectator would have been delighted by the still life details, by the wheelbarrow in the foreground loaded with vegetables. There is a study for the bullock in Vienna and a drawing for the milkmaid at Besançon. See also Plate 31.

17. Landscape with Philemon and Baucis. Panel, $58\frac{3}{5}$ $\times 82\frac{1}{4}$ in. Vienna, Kunsthistorisches Museum.

In the *Metamorphoses*, Book 8, Ovid tells the story of Philemon and Baucis. Jupiter and Mercury visited the earth in disguise. Nobody would give them food or shelter, except this elderly couple who, although poor, offered the gods all that they had. As a reward, they and their cottage were saved from the terrible flood with which the gods punished the inhospitable inhabitants of the country.

Rubens has used this story as an excuse for a great storm landscape. He never sold this picture, which was painted about 1625 and is listed in the inventory of his estate. It is an artificially composed scene and, in contrast to the earlier Dresden *Boar Hunt* (Plate 12), violence in nature rather than the physical energy of the human beings is the theme.

18. The Reception of Marie de' Medici at Marseilles, 3rd November 1600. Canvas, 155×116 in. Paris, Louvre. In 1622, Rubens paid his first visit to Paris to discuss with Marie de' Medici, the Queen Mother, her plans for the decoration of two galleries in the recently completed Luxembourg palace. Rubens was fresh from the Jesuit ceiling decoration and the Queen's advisor, the Abbé St. Ambroise, publicly declared that Rubens was the only artist in Europe capable of completing such a huge assignment, that Italian painters could not do in ten years what Rubens had promised to deliver in four. It was agreed that Rubens should be paid 20,000 crowns. At the end of May 1623 nine of the pictures were ready to go to Paris. The Queen expressed complete satisfaction. In February, 1625, Rubens was in Paris with the remaining 13 pictures; he supervised their hanging and was able to gauge the reactions of the Court. For the first gallery, Rubens had to paint twenty-one pictures - which were to line two long walls - commemorating several rather delicate episodes in the life of the Queen, who was the daughter of Francesco de' Medici, the Grand Duke of Tuscany. Rubens had actually witnessed one of the events he had to paint, for he had seen her marriage by proxy to Henry IV when passing through Florence in 1600. After her husband's death, Marie tried to govern France, but her constant plotting against her son, Louis XIII, finally led to exile at Blois. She returned, after a reconciliation, but Richelieu finally engineered her downfall and she was expelled from France in 1630. Rubens made the most of this unpromising raw material. He firmly believed in the Divine Right of Monarchs and he flattered his patron with the whole armoury of allegory, comparing her birth to the Nativity, her marriage to the Sposalizio. Gods and goddesses attend her birth and supervise her education. Rubens in his letters shows himself to be fully aware of the delicacy of the situation. Several scenes in the cycle were deliberately misinterpreted for the benefit of the young Louis XIII. In the reception at Marseilles, we feel Rubens angling the commission in the direction of his own interests: he makes rather little of the Queen and rather a lot of the Sirens. The pictures now hang in a specially designed gallery in the Louvre. They exercised great influence on 18th and 19th century artists. Delacroix copied this particular scene and when in doubt over colour would take a cab to the Louvre to consult Rubens' paintings; Greuze climbed a ladder, to take a closer look; and even Cézanne made drawings from the series.

19. The Last Judgment. Panel, $72 \times 46\frac{3}{4}$ in. Munich, Alte Pinakothek.

Executed about 1620. Usually known as the "Small Last Judgment" to distinguish it from a larger painting by Rubens, which is also in Munich and which was commissioned in 1616 by the Elector Wilhelm for the Jesuit church at Neuberg. Oldenbourg's theory that Boeckhorst altered Rubens' design and added the arched zone at the top is contested by Held, who believes that the whole painting is autograph. A twentieth century spectator sees an "old master', stands back to analyse the composition, to segregate shapes and to read movements, and enjoys a great atomic cloudburst, a suspension of figures. Seventeenth century spectators still used religious pictures and often saw them in an atmosphere of music and prayer. They stayed in front of them longer than we; for this was plausible damnation. They were trained to focus on the details, they isolated and remembered them. The Last Judgment shows up Rubens' strongest points as an artist, since he was more successful in evoking a multiplication rather than a concentration of feeling. He was released and stimulated by a large scale. He understood subjects which have movement or direction implicit in their narrative. This is a 17th century challenge to Michelangelo and Tintoretto.

20. Detail of Plate 19.

21. The Lamentation Over the Dead Christ. Panel, $13\frac{2}{5} \times 10\frac{5}{8}$ in. Berlin Dahlem, Gemäldegalerie.

Executed about 1612-14. A painted sketch of this kind adds new dimensions to our conception of Rubens' religious art. In other paintings of this subject, for example, in Rubens' Lamentation in the Antwerp Museum, he concentrated on a very aggressive, three-dimensional conception, on the actual physical details of the laying-out, on Caravaggesque angles and deliberately ugly and shocking foreshortening. In this sketch, however, he reveals a new tenderness. Christ has become an Adonis figure and the women lament in ritualistic attitudes borrowed from classical sarcophagi. The darkness and the flickering torch reinforce associations with desolation and death. The scaled-down movements and tapering forms are also very appropriate to the small physical scale of the panel.

22. Portrait of Ludovicus Nonnius. Panel, $48\frac{1}{2} \times 39\frac{1}{2}$ in. England, Private Collection.

Painted about 1627. The sitter was the son of a Portuguese physician and was himself a Doctor of Medicine. He was the author of several Latin books and an expert on Greek islands and classical coins. He belonged to Rubens' circle of humanist friends in Antwerp, and Rubens mentions his books in letters of December 1625, April 1626 and August 1627. The marble bust represents Hippocrates. This portrait might have been made to commemorate Nonnius' book *Diaeteticon sive de re cibaria*, published in Antwerp in 1627. See also Plate 24.

23. Portrait of the Countess of Buckingham. Panel, $33\frac{1}{2}\times25\frac{3}{4}$ in. (A piece cut off at the bottom.) London, Dulwich College Gallery.

Catherine Manners was the 6th Earl of Rutland's only daughter. She was a Roman Catholic and married the Duke of Buckingham in 1620, when she was 17. Rubens made a detailed drawing of her head (now in the Albertina, Vienna) but he could not have seen the Duchess when he first met her husband in Paris in 1625, as she did not accompany him on this occasion. Rubens may well have painted this portrait, about 1625-7, from a model provided by another artist. He was probably dissatisfied with the painting, for he made several alterations while working on it and never completely finished it. He used the back of the panel to jot down ideas, swift chalk drawings of Hercules. Rubens' portrait can be compared with Van Dyck's painted around 1633 and now in the Duke of Rutland's collection. See Note on Plate 26.

24. Detail of Plate 22.

25. Detail of Plate 28.

26. The Apotheosis of the Duke of Buckingham. Panel, $25\frac{1}{8} \times 25\frac{1}{8}$ in. London, National Gallery.

A modello, made between 1625 and 1628, in connection with a ceiling painting executed for George Villiers, 1st Duke of Buckingham. The large picture made for the Duke's London residence, York House, on the Strand, was destroyed by fire in 1949, together with Rubens' equestrian portrait (see Fig. 4. Both were in the possession of the Earl of Jersey at Osterley Park). In this sketch, which is not the final modello for the ceiling, the Duke is flatteringly painted in the pose of Correggio's Resurrected Christ from the cupola of St. Giovanni Evangelista in Parma. He ascends to heaven, assisted by Minerva and Mercury, and watched over by the Three Graces. He triumphs over Envy and Anger.

Buckingham is painted wearing contemporary armour and the Order of the Garter.

Rubens first met the Duke in Paris in 1625. Buckingham went there to organise the marriage between Charles I and Henrietta Maria. The wedding by proxy was actually held inside the Luxembourg palace. Buckingham was obviously impressed by the Marie de' Medici cycle, for he immediately commissioned an allegorical equestrian portrait from Rubens. Buckingham and Rubens were in continual contact up to the Duke's assassination at Portsmouth in 1628. They were drawn together by diplomatic missions and artistic interests. Buckingham was a great collector and patron. He owned a large number of Venetian paintings and bought Rubens' collection of classical sculpture - plus 13 pictures - in 1627. On his death in 1628, he had over 30 paintings by Rubens and it was rumoured he had spent over 1,000,000 florins on works of art.

Buckingham was a favourite of both James I and Charles I, but as head of the Army and Navy his disastrous foreign policy led to increasing unpopularity and to organised Parliamentary opposition from 1625-28. Rubens' ceiling must have seemed particularly appropriate; a contemporary said that Buckingham "flew up, rather than grew up". Both Buckingham and Rubens were aware of the precarious position. In the equestrian portrait (Fig. 4) Charity (?) drags Envy by the hair. In a masque that Buckingham put on for the King and Queen in 1627 he appeared with Mercury, pursued by the hounds of Envy. An anonymous versifier, in a poem entitled "Felton Commended", refers to Rubens' picture and captures its mood and implications:—

... yet in a hautie vast
Debordment of ambition, now in haste,
The cunning Houndhurst must transported bee,
To make him the restorer Mercuie
In a heroic painting, when before
Antwerpian Rubens' best skill made him soare,
Ravished by heavenly powers, unto the skie,
Opening and ready him to deifie
In a bright blisfull pallace, fayrie ile.

Buckingham's allegory was the first "di sotto in su" (figures in steep perspective) ceiling painting to be seen in Britain. It must have been completed before Rubens began work on the ceiling for the Banqueting House at Whitehall. It is particularly appropriate that Charles I should have allowed the apotheosis of James I to be couched in the same terms as Rubens' glorification of his father's favourite.

27. Two Apostles. Panel, $13\frac{7}{8} \times 16\frac{1}{2}$ in. Capesthorne Hall, Cheshire. Lieut.-Col. Sir Walter Bromley Davenport. This study was made for an altarpiece of *The Assumption*,

painted in 1627 for the church of the Holy Cross in Augsberg, commissioned by the Imperial Captain of that city, Count Otto Heinrich von Fugger. The altarpiece was painted by Rubens' assistants. These studies throw light on Rubens' working methods; guided by autograph details, his assistants were able to make competent enlargements from his small scale modelli. Such studies were an important part of Rubens' studio properties. They could be filed away and used for the training of pupils or even used again for paintings of other subjects. An inventory made on Rubens' death

lists "a quantity of heads from the life on canvas and wood some by Monsieur Rubens some by Van Dyck".

28. Hélène Fourment in Her Wedding Dress. Panel, $63\frac{3}{4} \times 52\frac{3}{4}$ in. Munich, Alte Pinakothek.

Rubens married the 16-year-old Hélène Fourment in 1630. Her elder brother had married Isabella Brant's sister. She was the daughter of a prosperous Antwerp silk merchant and brought Rubens a substantial dowry, which included yards of expensive material for her trousseau. In spite of the traditional title, there is no real reason to assume that Hélène is wearing her wedding dress. A chalk drawing in the Boymans-van Beuningen Museum, Rotterdam, showing Hélène in less ornate costume and a less dramatic pose, must be a preliminary study for this portrait, which is dateable about 1630-2. See also Plate 25.

29. Self-Portrait. Canvas, $43 \times 33\frac{1}{2}$ in. Vienna, Kunsthistorisches Museum.

Rubens' marriage certificate of 1630 describes him as "Knight Secretary to His Majesty's Privy Council and Gentleman of the Household of Her Serene Highness Princess Isabella". This is how Rubens, "the Prince of Painters", liked to see himself; the self-portrait shows a professional court diplomat, with the sword that his rank entitled him to wear. Rubens never painted himself as an artist. Only one of Rubens' hands is gloved - a highly self-conscious, fashionable gesture, that he had learnt from Titian's male portraits. Rubens owned a self-portrait by Titian. Rubens could have seen Titian's Man with the Glove (Louvre) in the Gonzaga collection in Mantua and then again in 1629 after the collection had been sold to Charles I. We do not know for whom this work was intended but Rubens now usually produced self-portraits of this kind only on request. In 1623 he overcame his modesty and painted one for Prince Charles. In 1628, he sent a school replica of this picture to his French friend, Peiresc. A chalk drawing in the Louvre is a preliminary study for this portrait, which was painted about 1633-35.

30. Hélène Fourment in a Fur Wrap. Panel, $69\frac{1}{4} \times 32\frac{5}{8}$ in. Vienna, Kunsthistorisches Museum.

Painted about 1638. In his will, Rubens left his wife only one picture: it was known as "Het Pelsken" (The Fur). She was to have it without incurring any legal obligation to his estate. This painting was not popular with 19th century critics, who found it vulgar and under-idealised, and who resented Rubens' seeming exposure of his wife and private life. The painting was certainly inspired by Titian's half-length portrait of a *Girl with a Fur*. Rubens must have seen Titian's picture hanging in Charles I's private apartments in Whitehall. He made a painted copy of it, which can probably be identified with one of the four paintings made after Titian's Venetian courtesans mentioned in his inventory.

31. Detail of Plate 16.

32. Bacchanal (Copy after Titian's painting of *The Andrians*). Canvas, $78\frac{1}{2} \times 84\frac{1}{2}$ in. Stockholm, National-museum.

Executed about 1636-8, this is a free copy of one of the three

mythological paintings made by Titian for Alfonso d'Este between 1518-23. When Rubens was in Rome these pictures were on exhibition in the Aldobrandini Collection. These works exercised a great influence on many 17th century painters; the German art historian, Sandrart, tells us that he inspected them in the company of Claude, Duqesnoy, Poussin and Pietro da Cortona. Van Dyck's drawing of The Andrians, made in 1622-23, is now in the Devonshire Collection at Chatsworth. Rubens' copy is a late work and cannot have been made from the original painting, for this was shipped off to Spain in 1638. Rubens could have been working from detailed drawings, or from copies that were on the Antwerp art market in the late 1630's. This Bacchanal illustrates a passage from the Imagines of Philostratus which describe the pleasures of the island of Andros, blessed by Bacchus with a never-ending stream of wine. Rubens made this copy for himself and it is listed in the inventory of his estate. In the 18th century, Raphael Mengs took exception to Rubens' version, which, he said, was "like a book translated into Flemish which has retained the thought but lost all the grace of the original language". It is true that Rubens has altered the meaning of Titian's picture. A Dionysian ecstasy has become a drunken orgy and in the transformation at least one beautiful youth has grown into a middle-aged lecher. Rubens has extended the space and implied far greater distance. He has emphasised the curvature of the tree-trunks and has re-animated the surfaces. It would be interesting to know what Philip IV made of the contrast. For, having bought Rubens' Bacchanal, he could then compare it with Titian's original.

33. The Rape of the Sabines. Panel, $66\frac{3}{4} \times 92$ in. London, National Gallery.

Romulus the founder of Rome encouraged settlers by offering asylum to homicides and runaway slaves. These refugees needed wives. Romulus organised games to be held in honour of the god Consus and invited his neighbours, the Latins and the Sabines, to come to the festival. At a signal from Romulus, the Romans attacked their guests and carried off the young women.

Executed about 1635. Roger de Piles, who described this painting when it was in the Duc de Richelieu's collection in the 1680's, considered it a gay, light-hearted picture. He contrasted it with *The Massacre of the Innocents* (Munich, Alte Pinakothek) also in the same collection; "Un desordre de joye" as against "Un desordre de cruante". De Piles, who was heavily influenced by French academic ideas and Poussin's Theory of the Modes, thought that its gaiety depended upon the festive, Ionic architecture, the fresh colours and the clear sky. He pointed out that the central Sabine is a portrait of Hélène Fourment and somewhat fancifully decided that the Roman attacking her was a self-portrait of Rubens.

34. The Anger of Neptune ("Quos ego"). Panel, $19\frac{1}{4} \times 25\frac{1}{4}$ in. Cambridge, Mass., Fogg Art Museum.

In April 1635, the new Governor of Belgium, the Cardinal Infante Ferdinand, Philip IV's brother, made a ceremonial entry into Antwerp. The streets and squares were decorated with painted stage sets, floats and triumphal arches. Many of these temporary decorations alluded to current events and

warned the new Governor of decline in commerce and the disastrous war against Holland. The whole scheme was very expensive and had to be partly paid for by an extra tax on beer. The Town Council put Rubens in charge of the project; the designs were farmed out to other artists for execution. We can reconstruct the ensemble, since Rubens' friend, Gaspar Gevartius, Secretary to the city, was commissioned to write a learned Latin explanation of the decorations. His book, the *Pompa Introitus Ferdinandi*, published in 1642, was illustrated with engravings by Theodore van Thulden, an artist who had worked under Rubens on the project. The Cardinal was so impressed by Rubens' display that he declined a gift of 9,000 florins offered him by the city and instead chose the best pictures from one of the gateways and ordered Rubens to retouch them.

The "Quos Ego" is Rubens' modello for the left wing of the "Stage of Welcome". This gigantic triptych had wings set out at an angle to the central section. It was erected on the Huidevetterstraat, in front of St. George's church. In the centre a maiden personifying Belgium kneels before the Governor and asks for his protection. In the right wing the Cardinal meets Ferdinand, King of Hungary at Nordlingen. On the left the "Anger of Neptune" glorifies, in the terms of Virgil's Aeneid (Book I, 125-140), Ferdinand's dangerous voyage from Barcelona to Genoa. In the Aeneid, Neptune defeats the hostile winds and grants Aeneas a safe passage to Africa. In the painting Neptune protects the Spanish galleons, which had been nearly wrecked on the voyage, from the north wind. This wind was then regarded as being particularly dangerous on sea routes between Italy and Spain.

The large picture that decorated the arch was painted by Rubens' assistants and is now in Dresden.

35. The Rape of Hippodameia. Panel, $10\frac{1}{4} \times 15\frac{3}{4}$ in. Brussels, Musée des Beaux-Arts.

Executed about 1636-8. In 1636, Philip IV commissioned from Rubens a series of paintings to hang in his hunting lodge, the Torre della Parada, which was about ten miles outside Madrid. Over 100 pictures, most of them illustrating episodes from Ovid's *Metamorphoses*, were needed to decorate twelve large rooms on the first floor and eight on the ground floor. The majority of the paintings were destroyed when the building was sacked during the War of Succession in 1710. Rubens, who may have first discussed this commission on his visit to Spain in 1628, was working on the project from 1636, but failed to complete it before his death in 1640. During this period his health was poor and he suffered from agonizing attacks of gout. The large pictures were painted by assistants who followed Rubens' modelli.

This sketch illustrates Ovid's Metamorphoses XII. Pirithous, the leader of the Lapiths, invited his friend Theseus and the Centaurs to his wedding feast. During the festivities Eurytus, the fiercest of the Centaurs, drank too much wine and tried to rape the bride, Hippodameia. The other Centaurs seized the Lapith women. Theseus rescued Hippodameia and killed Eurytus, by braining him with a golden goblet. Rubens has borrowed his Theseus from Michelangelo's drawing (now at Windsor) showing archers shooting at a Herm. Rubens retains an ingenious memory of this source: Hippodameia's feet form the tip of an arrow head

which is clearly defined by the Lapith's spear and the old woman's arm. Strong movement from left to right is characteristic of Rubens' late works. Delacroix especially admired this modello for the lightness and transparency of its colour and he analysed it carefully in his journal.

36. Saint Idelfonso Receiving the Chasubule from the Virgin (Central Panel of the Idelfonso Altarpiece). Vienna, Kunsthistorisches Museum. 139×93 in.

Saint Idelfonso was a 7th century Archbishop of Toledo who wrote a defence of the doctrine of the Immaculate Conception. He fasted for 3 days before the Feast of the Assumption and on that day he entered his church and saw the Virgin Mary seated in the choir stall amid streams of unearthly light. The choir stall was filled with saints singing psalms in her praise. In gratitude for his defence, the Virgin presented him with a specially embroidered chasuble.

Painted 1630-32. In 1629, the Archduchess Isabella ordered this altarpiece for the altar of the St. Idelfonso fraternity chapel inside St. Jacques sur Coudenberg, the Parish Church of the Court in Brussels. The Archduke Albert had founded the confraternity at the end of the 16th century when he was Governor of Portugal. Its function was to promote loyalty to the Royal Family and the Flemish branch was established in 1603. Its membership was exclusive, being made up of nobles and court officials. The saints in the central panel are St. Barbara, St. Catherine, St. Agnes and St. Rosalie. In the left wing the Archduke Albert (died 1621) kneels at a prie dieu accompanied by his patron saint Albert of Lüttich. On the right panel his wife Isabella is attended by St. Elizabeth of Hungary. On the outside of the wings Rubens painted the Holy Family under an apple tree. A modello in the Hermitage, Leningrad, shows that Rubens planned a single panel, rather than a triptych. This scheme was probably unacceptable for his altarpiece was meant to replace an old Flemish triptych. As often happens in Baroque painting, the spectator is granted supervisionary powers. He is allowed to see two people having a vision of a saint who is in turn having a vision. Also typical of 17th century religious painting is the method of emphasising divinity by rays of light.

37. Detail of Plate 38.

38. Landscape with the Château de Steen. Panel, $54 \times 92\frac{1}{2}$ in. London, National Gallery.

Painted after 1635, this landscape includes an idealised view of Rubens' country house and estate, the Château de Steen, which was situated between Brussels and Malines, and which he bought in 1635. Rubens' son, Albert, told Roger de Piles that his father acquired the house so that he could paint in peace and study landscape. This highly finished picture was painted for Rubens' own pleasure and in 1645 Albert who had been left one half of the actual château bought it out of his father's estate for the large sum of 1,250 gilders. In 1802, an English dealer bought the *Château de Steen* and the Wallace Collection landscape (Fig. 12) from the Palazzo Balbi in Genoa. These two pictures are almost identical in size and were probably conceived as a pair, as demonstrations of totally different weather effects. They had an important influence on English landscape painting. The

Château de Steen belonged to Constable's patron, the connoisseur Sir George Beaumont, who allowed artists access to his paintings and on one occasion even lent Constable a picture by Rubens. Constable lectured on Rubens' land-scapes at Hampstead in 1833. He said: "In no other branch of art is Rubens greater than in landscape - the freshness and the dewy light, the joyous and animated character which he has imparted to it, impressing on the level monotonous scenery of Flanders all the richness which belongs to its noblest features. Rubens delighted in phenomena - rain-bows upon a stormy sky - bursts of sunshine - moonlight - meteors - and impetuous torrents mingling their sound with wind and wave. Amongst his finest works are a pair of land-scapes, which came to England from Genoa, one of which is now in the National Gallery."

39. "La Kermesse Flamande". Panel, $58\frac{5}{8} \times 102\frac{3}{4}$ in. Paris, Louvre.

Painted in the first half of the 1630s. In this work we see Rubens trying to paint a typical Bruegel subject again from nature. This theme, a peasant wedding, was first made famous by Peter Bruegel the elder; it maintained its popularity and was kept alive as a best seller by his son Peter Bruegel the younger who lived off pastiches of his father's work until the early 1630's. Rubens has produced a deliberately humorous picture of a type that would be especially amusing to aristocrats or the urban upper middle classes and it is hardly surprising to find the Kermesse in Louis XIV's collection in 1685. In the 1630's, Rubens made several experimental genre paintings. He became interested in the work of Adriaen Brouwer, a Flemish artist who had made his reputation in Holland as a painter of peasant brawls and tayern scenes. Brouwer, who was a Catholic, arrived in Antwerp in 1631. He seems to have been a spy or agent and it was probably some political intrigue that first brought him into contact with Rubens, who took him into his own house for a short time. In 1632, Rubens owned one of his pictures, Peasants Dancing in a Landscape. Rubens' Kermesse may well have been painted before 1636, for in that year two "Flemish weddings" by him are listed in an inventory.

It has recently been suggested that in the *Kermesse* Rubens has collaborated with Saftleven who may have been responsible for the still life details and landscape. Rubens' preliminary studies - rapid, improvised pen and ink drawings for the chains of dancing figures - are in the British Museum (see Fig. 5).

40. Detail of Plate 38.

41. Landscape with a Rainbow (detail of Fig. 12). Panel, $53\frac{1}{4} \times 92$ in. London, The Wallace Collection. Painted after 1635. See note on Plate 38.

In 1841, Cotman went on a pilgrimage to Wolterton, especially to see this painting. During the visit, a storm blew up, and he saw a rainbow that he admitted was very like that painted by Rubens.

42. The Meeting of Abraham and Melchizedek. Panel, $26 \times 32\frac{1}{2}$ in. Washington, D.C., National Gallery of Art. Executed 1627-8. A sketch for one of a series of seventeen tapestries, commissioned by the Archduchess Isabella, and

illustrating the doctrine of the Eucharist. They were woven for the Convent of the Barefooted Carmelite nuns in Madrid. Christian allegory is used to propagate the doctrines of the Catholic Church: the Holy Sacrament confounds the heretics, the idolators and the philosophers. Since the Middle Ages, the meeting of Abraham and Melchizedek (related in Book of Genesis), had been regarded as a prefiguration of Christ's invention of the Holy Communion. Melchizedek, high priest and king of Salem, gave Abraham bread and wine. In the actual canon of the Mass, Melchizedek is mentioned as having offered Abraham "the holy sacrifice, the immaculate Host". The story was also taken to symbolise the preeminence of the Church over the State, or secular power. Rubens had already depicted the meeting in one of the panels on the ceiling of the Jesuit church in Antwerp (see note to Plate 9).

Rubens was a deeply committed Catholic, and throughout the 1620s he had been working for the return of Protestant Holland to the fold of Spain and the Catholic Church. After completing the commission for the tapestry designs, he was able to write - in 1628 - "Religion takes hold on men's hearts more than any other emotion."

Designing for reproduction in tapestry involved a vast amount of preliminary work. Rubens made small scale modelli (like this one), which he then had to reverse. He then provided enlargements to scale of the mirror image, as patterns for the tapestry workers, who, in the weaving, automatically reversed the image so that it conformed with the original design.

Rubens' designs involved a typical form of Baroque illusionism. The scenes appear as though they themselves were on tapestries, which are caught up on classical columns or held by angels. In the finished work, a tapestry reproduces a painting of a tapestry. Rubens had first used a scheme of this kind in *The Gonzaga Family Adoring the Holy Trinity*, a key picture of his early Mantuan period.

43. Hercules and Minerva Fighting Mars. Water-colour over black chalk, on light brown paper, $14\frac{1}{2} \times 21\frac{1}{4}$ in. Paris, Louvre (Cabinet des Dessins).

Executed about 1635-7, this is one of several allegorical compositions in which Rubens, after retiring from his diplomatic career, expresses his hatred of war and takes a pessimistic view of European politics. This drawing is closely related by its theme and form to Rubens' oil on paper sketch for The Horrors of War in the National Gallery (Fig. 11), Rubens' finished painting, which was probably made for the Grand Duke of Tuscany, was delivered to Florence in 1638. The present sketch may be an early idea for the allegory. This drawing illustrates the ability of Rubens to think immediately in terms of colour. It shows him taking his drawing technique towards his painting. In 1639 he complained that he could no longer make small scale drawings because his hands were crippled by gout. There is an oil sketch of the central group in the Boymans-van Beuningen Museum, Rotterdam.

44. Bathsheba Receiving the Letter from King David. Panel, $68\frac{7}{8} \times 49\frac{3}{8}$ in. Dresden, Gemäldegalerie.

An illustration of Samuel 2, Chapter 11. Bathsheba was the beautiful wife of Uriah, a Hittite captain. While walking on

the roof of the palace, King David caught sight of her bathing. He sent for her, and made love to her, and engineered her husband's death in a battle.

Rubens apparently painted this subject only once. The picture, executed about 1636-8, is listed in the inventory of his collection, where it might well have formed an Old Testament companion-piece to *Hélène Fourment in a Fur Wrap* (Plate 30).

It is interesting to compare Rubens' Bathsheba with Rembrandt's painting of 1654. Rubens has adopted a straightforward Venetian interpretation of the subject; the architectural elements are neo-Venetian, and in parts reminiscent of Veronese. He is also concerned with physical activity: the letter is about to be handed to Bathsheba, who is just beginning to take an interest in it. Rembrandt adds new dimensions of tenderness and insight to the very simple Biblical narrative. His Bathsheba is no commonplace Old Testament prostitute. Seemingly unaware of her body, unconscious of her nakedness, she has read the letter and ponders on its contents. An old woman kneels, with almost holy humility, to dry her feet. Rembrandt's painting is about the effect of a letter, whereas Rubens, in a more light hearted vein, has created a picture about a seduction. And it is an appropriately seductive image. Everything about the figure of Bathsheba, from the close pressed knees, exposed thigh and tight breasts to the provocatively loose and scanty clothing, contributes to the erotic mood.

45. Portrait of Hélène Fourment with Two of Her Children. Panel, $44\frac{1}{2} \times 32\frac{1}{4}$ in. Paris, Louvre.

This picture, executed about 1636-7, is unfinished. The children are Clara Johanna (born January 1632) and Frans (born July 1633). It seems possible that Rubens intended to make a much larger picture. The pair of outstretched hands that can be just seen in the lower right hand corner belonged to Hélène's daughter, Isabella Hélène, who was born in 1635. A drawing in the Louvre shows this child with arms outstretched and hands in a position corresponding to those in the painting. Rubens must have wanted to include this child wearing reins, perhaps attended by a nurse. This part of the picture might have been sketched in very lightly and cut off at a later date. This portrait once formed part of Louis XV's collection.

46. Sunset Landscape. Panel, $19 \times 32\frac{7}{8}$ in. London, National Gallery.

A private work, painted by Rubens for his own pleasure. It must date from after 1635, although as it belongs to a series of late landscapes that are undocumented, and as there is less variation in his style during the 1630s, it is difficult to be in any way exact about the particular year. It was only late in life that Rubens began to explore what might be called the "therapeutic" qualities of landscape. He suggests greater space by extending the format horizontally. Recession he will suggest through the direction of the brush-strokes, and also by clear contrasts in the scale of objects in the foreground and distance. In the Sunset Landscape, the new interest in repose

is symbolised in the figure of the shepherd playing his pipe. Constable was particularly susceptible to the tonality of this kind of late Rubens. Before painting a picture of this type, Rubens would have made countless drawings and studies, sometimes in colour, out of doors. In a drawing in the British Museum (Fig. 6), we can almost watch the artist at work, learning about light. The study shows a group of trees reflected in a pool. Below Rubens had written some notes: "The reflection of the trees in the water is browner and more perfect in the water than the trees themselves."

47. Landscape with Figures. Panel, $20\frac{3}{4} \times 38\frac{3}{4}$ in. Vienna, Kunsthistorisches Museum.

Executed after 1635. In the 1630s, Rubens made several paintings of "Gardens of Love", experiments in high class genre at the opposite end of the scale from "low life" scenes of peasant merry-making (such as Plate 39). Rubens' interest in, and treatment of, such themes grew out of studying 16th century representations of Gardens of Delight, as well as engravings depicting seasonal recreations. He must have known the engraved Seasons by Cornelius de Waal; and he actually reworked a drawing by Vermeyen (now in the Albertina, Vienna) showing a group of lovers round an ornamental pool. It is not surprising to find the Landscape with Figures should have been listed in an 18th century inventory as Printemps (Spring). These late Rubens pictures of elegant pastoral diversions were greatly appreciated in 18th century France and, in particular, by Watteau, whose own fragile and elusive imagery they partially anticipate.

48. The Three Graces (detail). Panel, 87×71 in. Madrid, Prado.

Painted in the second half of the 1630s. The Three Graces was still in Rubens' possession at the time of his death; and the picture was bought from his estate by Philip IV of Spain. The subject and Rubens' attitude were here at one, for in Greek mythology, the Graces were simply personifications of charm and grace in nature and in moral action. Even their names carried clear visual implications - Aglaia (brightness); Euphrosyne (joyfulness); and Thalia (bloom). Rubens paints their attributes: the myrtle, the rose and musical instruments.

Within the classical definition of ideal form, Rubens has elaborated one of his own. Hélène Fourment is clearly recognisable as the left hand Grace, just as she had been recognisable to the Governor of Antwerp as Venus in a late fudgement of Paris. Most of Rubens' late figure paintings are really about the existence, judgement and contemplation of beauty. It is interesting to learn, though, that some of his late female nudes met with opposition in puritanical Spanish circles. Cardinal Ferdinand, writing to Philip IV about the late fudgement of Paris (Prado), explained that the artist had not wished to cover up the nudity of the figures because he regarded such concealment as "la valentia de la pintura". Looking at The Three Graces, we might well remember that Rubens took to heart certain classical mottoes, among them Juvenal's "In mens sana in corpore sano".